PHOTOGRAPHING
Y⬤UR GARDEN

PHOTOGRAPHING
YUR GARDEN

GAIL HARLAND

GUILD OF MASTER CRAFTSMAN PUBLICATIONS

First published 2003 by
Guild of Master Craftsman Publications Ltd,
166 High Street, Lewes,
East Sussex BN7 1XU

ISBN 1 86108 361 0
A catalogue record of this book is available from the British Library.

Publisher: Paul Richardson
Art Director: Ian Smith
Production Manager: Stuart Poole
Managing Editor: Gerrie Purcell
Commissioning Editor: April McCroskie
Editor: James Evans

Cover and book design: Chris Halls, Mind's Eye Design Ltd, Lewes
Typeface: Avenir

Colour origination: Universal Graphics Pte Ltd, Singapore
Printed and bound: Stamford Press Pte Ltd, Singapore

To Ashley and Jonathan, with love.

ACKNOWLEDGMENTS

Grateful thanks go to the all those owners who generously allowed me to include photographs of their gardens: Lesley Orrock, Moverons, Brightingsea, Essex; Mr and Mrs John Ineson, Highfields Farm, Bures, Suffolk; Dr Janet Sleep, The Harralds, Gissing, Norfolk; Mrs Hale, Heron House, Aldeburgh, Suffolk; The Godinton House Preservation Trust, Kent; Maryanne Nicholls, High Hall, Nettlestead, Suffolk; Lady Cave, Stanford House, Aldeburgh, Suffolk; Mrs Coode-Adams, Ferringbury Manor, Essex; Fiona Edmond, Green Island, Ardleigh, Essex; Hew Stevenson, Columbine Hall, Stowupland, Suffolk; Lord Blakenham, Blakenham Woodland Gardens, Suffolk; D.G. Lennox, Saxham Hall, Suffolk; Mr R. Creasey, Creeting St Mary, Suffolk; Mr and Mrs Ward, Willow Wood, Suffolk; Mavis Smith, Suffolk; Royal Horticultural Society, Hyde Hall, Essex; Mrs Raven, Docwra's Manor, Cambridgeshire.

I would also like to thank Kate Jackson and Ian Wilson who waded through the manuscript for me, and April McCroskie and James Evans at the Guild of Master Craftsman Publications. Dawn Hodgson at Jessops, the Buttermarket, Ipswich, kindly arranged the loan of a camera when mine gave up on me just as the book deadline was looming. Ian and Adele Wilson, Helen Norris and Nigel Macbeth let me photograph their cameras. Finally, special thanks are due to Ashley and Jonathan Harland who spend a sizeable part of their school holidays carrying my camera bag and setting up my tripod for me.

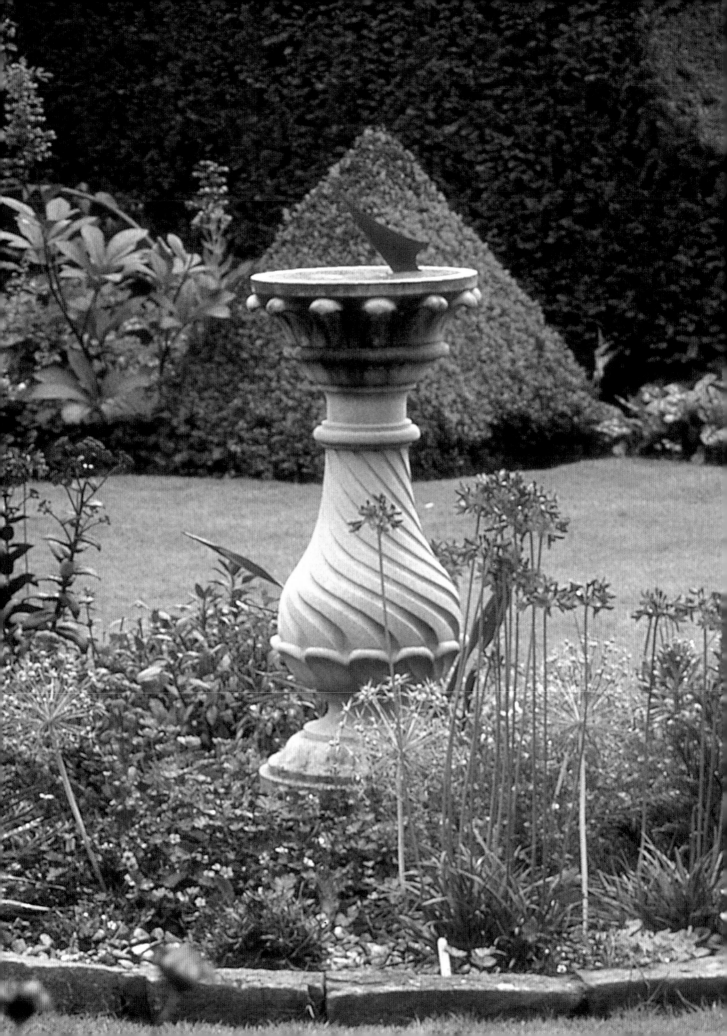

CONTENTS

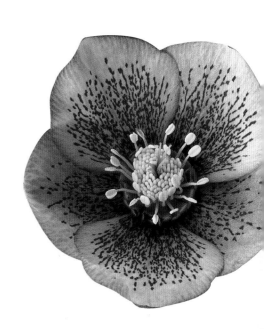

Introduction 1

Equipment
The camera 16
Lenses 24
Light meters and flash 30
Film 34
Accessories 40

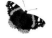

Using the equipment
Composition 52
Exposure 68
Lighting 74

Subject selection
The broad picture 86
People and pets 98
Wildlife in the garden 108
Plant portraits and partnerships 114
The garden through the seasons 128
Other people's gardens 136

Additional considerations
Archival and display of your work 142
Selling your work 148
Learning from your mistakes 154

Glossary 169

Bibliography 171

Useful addresses 172

About the author 174

Index 175

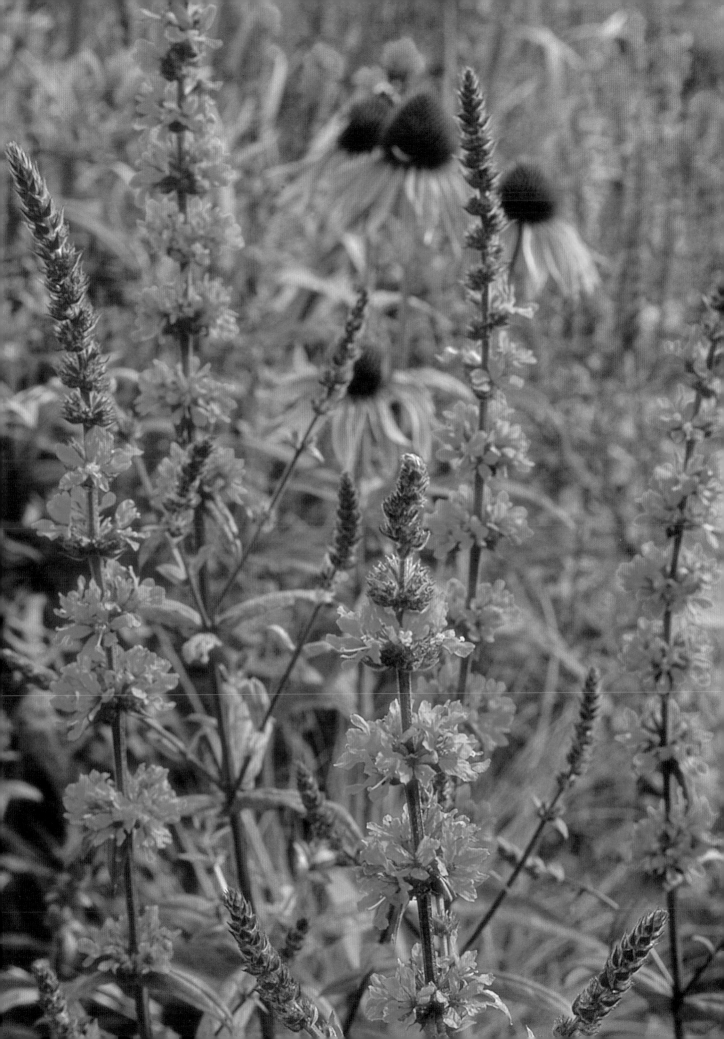

INTRODUCTION

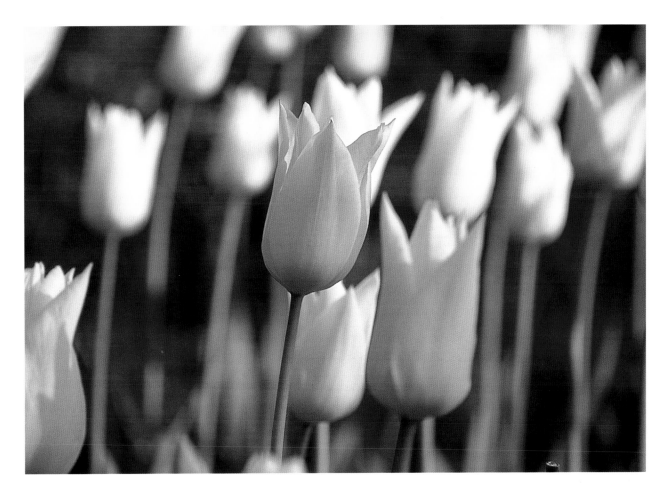

We garden for many different reasons: because we love beautiful flowers or want to grow our own food; because the garden is there and we feel obliged to do something with it; or perhaps because of inspiration gained from a television programme. You may be a gardener by trade, by inclination, or by breeding – one of a family of gardeners. Approaches to gardening also differ. To some it is a competition to produce prize-winning specimens, while to others it is a science with exact formulae for feeding each plant, or an art using the colour of plants to create living paintings. Gardening can be a spell that bewitches you and leads to obsession.

I was particularly pleased with this spring display of *Tulipa* 'White Triumphator' in my own garden, and was glad that I recorded it as during the following winter the vast majority of the bulbs were dug up and eaten by rats.
28–80mm zoom lens, Fuji Astia, tripod, 1/125sec at f/5.6

There is a pleasing combination of contrasting shapes and toning colours in this planting of lythrum and echinacea. Successful plant partnerships such as these are worth recording so that you can repeat them at home.
28–80mm zoom lens, Fuji Velvia, tripod, 1/20sec at f/11

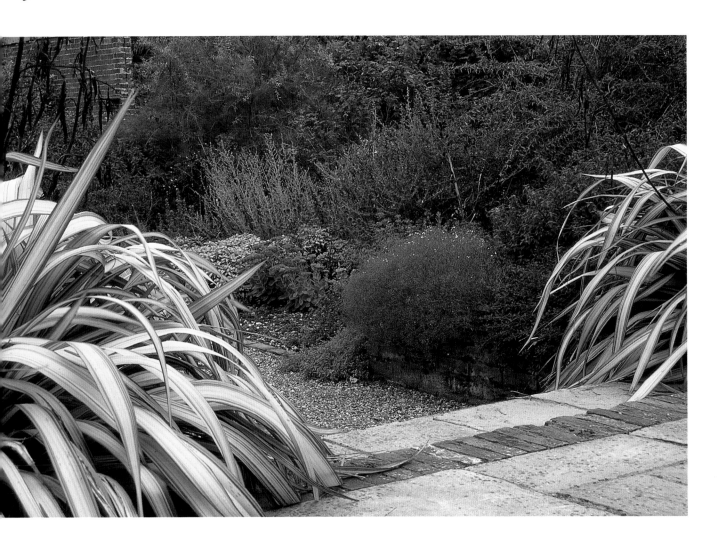

Variegated phormiums on either side of steps at Moverons in Essex, England, mark the entrance to the walled garden. *28–80mm zoom lens, Fuji Velvia, tripod, 1/4sec at f/27*

Whatever the reason for gardening, there usually comes a time when the gardener wants a permanent reminder of the often transient beauty of the results of his or her labours. One of the joys of a garden is that it is never the same two days running. Even when using long-flowering plants in a gentle climate, the growth and eventual decay of organic material, combined with the varying nature of light, means that views change constantly.

It is natural to want to capture particular moments in the life of a garden. The long-awaited first flowering of a seed-raised rarity may demand a celebratory photograph, or there may be particular combinations of plants that you find pleasing and want to record. In the depths of a cold, dark winter when

The curved path here at Highfields Farm in Suffolk, England, leads the eye through an image framed by conifer branches. *28–80mm zoom lens, Fuji Velvia, tripod, 1/8sec at f/9.5*

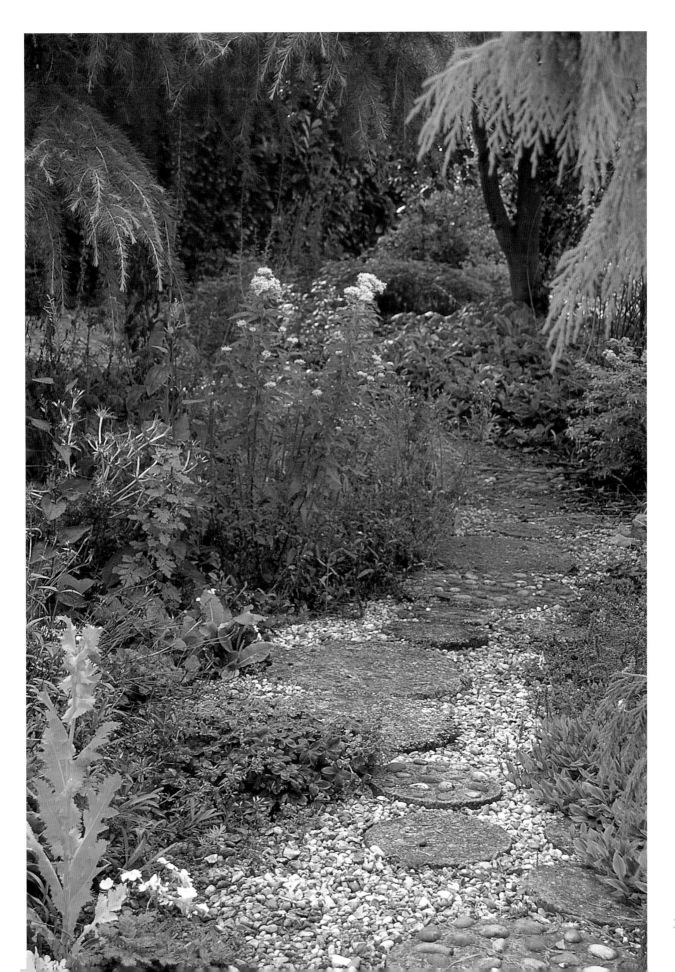

Garden features such as this attractive tree seat around a pear tree at High Hall in Nettlestead, England, may be copied in your own garden.
28–80mm zoom lens, Fuji Astia, 1/60sec at f/5.6

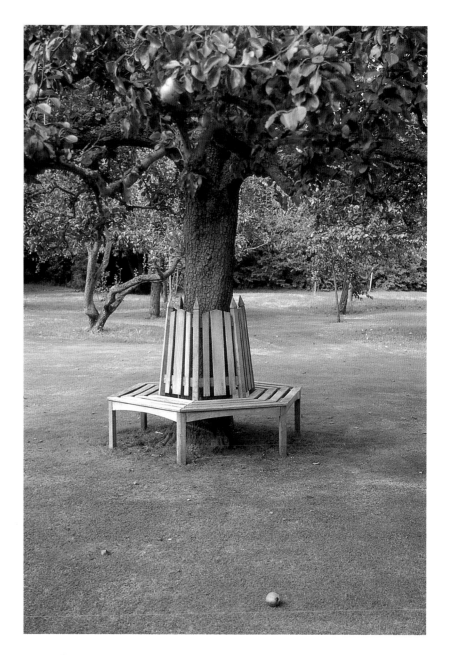

Many appealing pictures can be taken through the winter months. This image of the dwarf *Iris* 'Harmony' needed an exposure setting one-and-a-half stops greater than that suggested by my light meter in order to compensate for the light reflected by the dusting of snow.
Sigma 50mm macro lens, Fuji Astia, 1/45sec at f/13

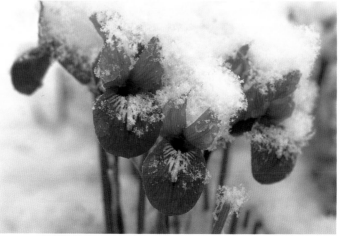

gardening is unappealing even if not impossible, photographs of your garden taken in spring or summer can raise the spirits and encourage planning and planting for the next season. Those proud of their creativity in the garden may want to send pictures of it to friends and relatives.

Of course, photographs of a garden may not always be an ego boost. They can reveal flaws in design, gaps in planting and unappealing colour combinations that the gardener may have overlooked. Looking at photographs can be revealing and helpful in the critical appraisal of a garden, encouraging changes in future years. If a particular garden project is planned, taking

I admired the contrasting textures between the stone, foliage and flowers here at Hyde Hall in Essex, England. The painted lady butterfly moved into place on the stone just as I took the picture.
28–80mm zoom lens, Fuji Velvia, 1/60sec at f/11

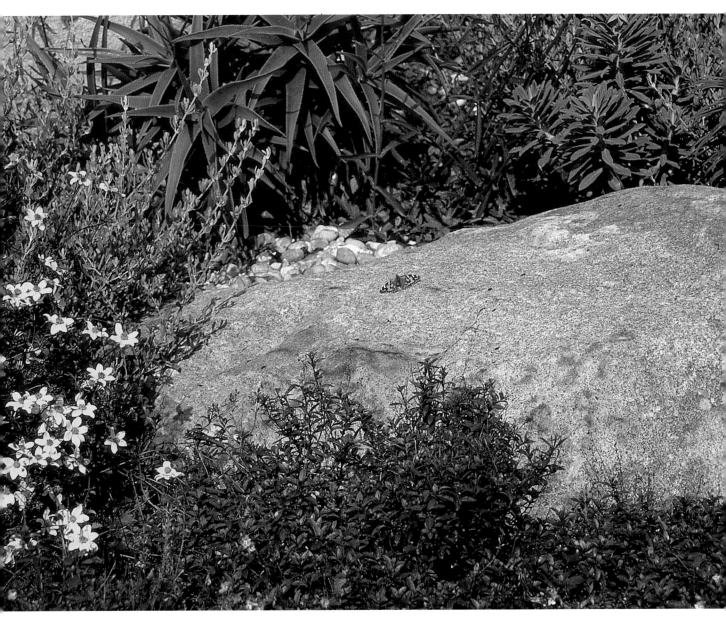

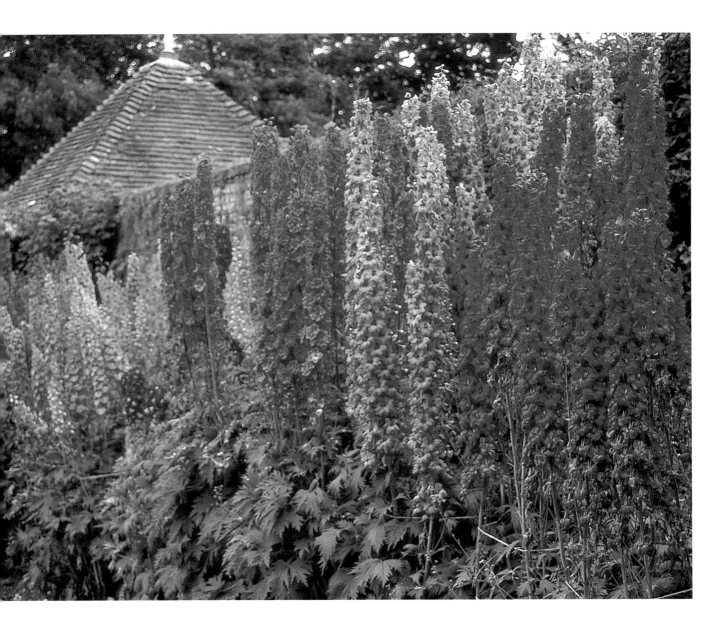

Fuji Astia transparency film was chosen to record the colour of these dramatic spires accurately. Slight underexposure has deepened the blue of the flowers. Taken in the Delphinium Society's border at Godinton House in Kent, England.
28–80mm zoom lens, Fuji Astia, 1/60sec at f/8

before and after pictures is a useful record of the changes made, and may prove fascinating in future years as the project matures and the memory of the 'before' has blurred.

Many of us like to visit other gardens as a way of seeking inspirational ideas to bring back to our own. Taking your camera with you ensures that you can have pictures to serve as aide-memoires to those features that you would like to replicate in your own garden. Pictures of plants you have seen in a botanic garden may help you to identify something in your own garden. And, of course, if you have a picture of an unknown plant you can always ask an expert to identify it for you.

Those people with a passion for a particular plant group may want to record the individual plants in their own collection. They may also wish to seek out and photograph in other gardens examples of plants that they aspire to own. Someone who is especially knowledgeable on a plant group, or on other aspects of gardening such as design, or those familiar with famous gardens, may be much in demand for lecturing to horticultural societies. Owning a collection of photographic images would be invaluable for this.

Plant breeders, or indeed any gardener who has discovered a new cultivar, will find a photograph a priceless supplement to a pressed specimen when documenting their new treasure.

Pages 7–10: A collection of flower portraits to delight any peony enthusiast. These were all taken with Fuji Astia film for accurate colour rendition, and using a tripod to avoid camera shake and allow wider apertures. This gives greater depth of field, revealing intricate details.
Below: *Paeonia mascula.*
28–80mm zoom lens,
1/125sec at f/19

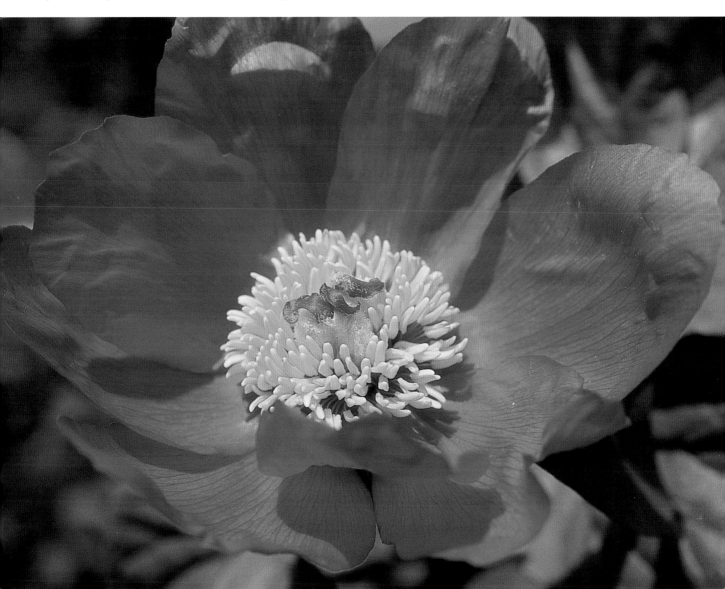

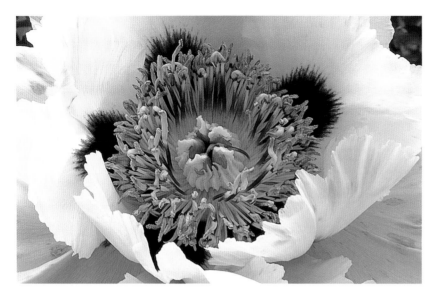

Paeonia rockii 'Rock's Variety'.
28–80mm zoom lens,
1/30sec at f/22

Paeonia 'High Noon'.
Sigma 50mm macro lens, 1/30sec
at f/45

Paeonia mlokosewitschii.
Sigma 50mm macro lens, 1/90sec
at f/19

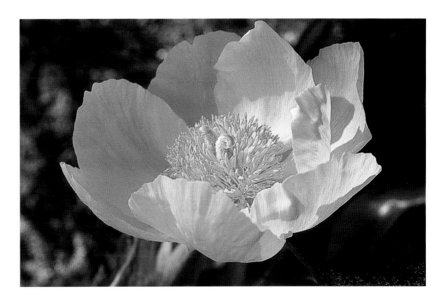

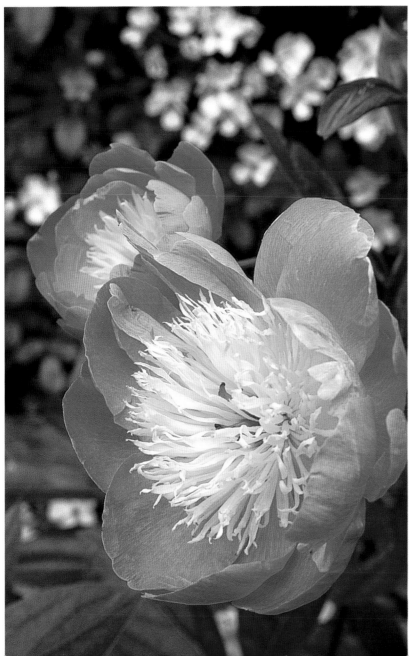

Paeonia lactiflora 'Bowl of Beauty'.
Sigma 50mm macro lens,
1/45 sec at f/16

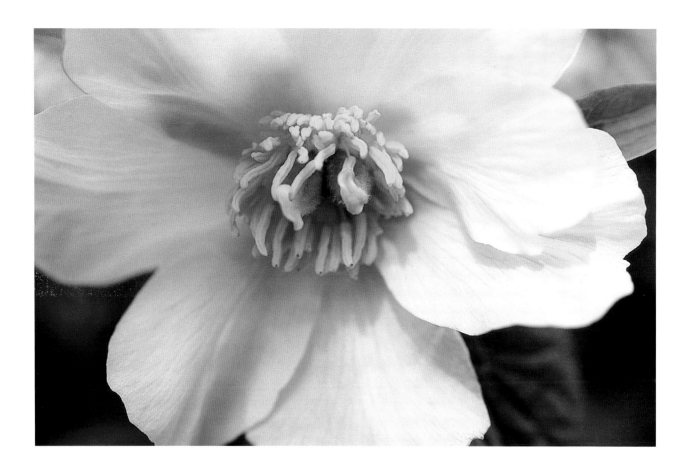

Paeonia emodi.
28–80mm zoom lens,
1/30sec at f/22

The pressed specimen will fade as it dries, whereas a photograph (taken with suitable film) can provide a more faithful representation of the living colour. Looking at the layout of botanical illustrations can be helpful in deciding how to go about taking a photograph for this purpose, and separating out some petals from one flower may reveal helpful diagnostic details that will identify an individual cultivar.

This close-up portrait of a *Dendrobium* orchid hybrid has been underexposed slightly to bring out the rich lime-green colour of the petals and the velvety texture of the lip. One flower has been pulled apart to show the structure more clearly. *Sigma 50mm macro lens, Fuji Velvia, tripod, 3secs at f/45*

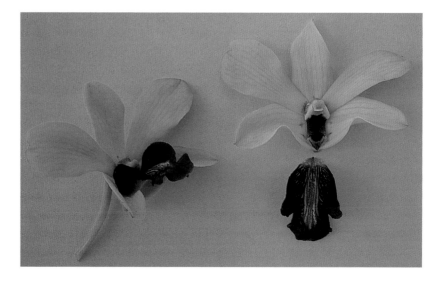

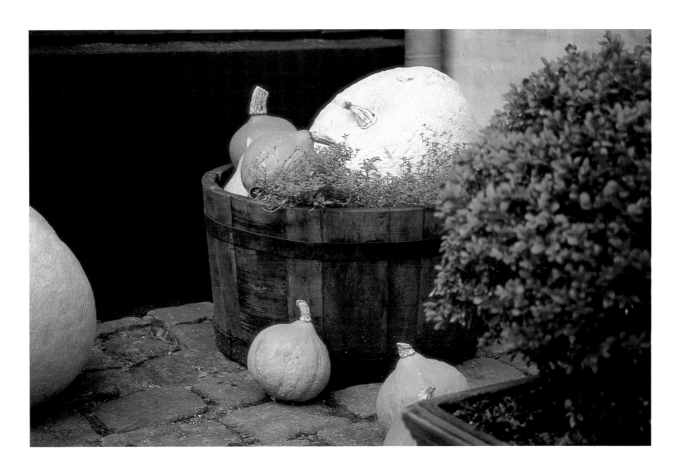

Of course, many of us like taking photographs for their own sake and any garden can be a source of pleasing images with the plants, human visitors and wildlife that it may attract. Huge, immaculately maintained public gardens with formal planting and expensive hard landscaping are not the only suitable subjects. Your own garden has a wealth of pictures of varying pattern, colour and form that can translate into

This colourful display of pumpkins attracted my attention when on holiday in Denmark.
Canon Z115 (35mm compact camera), Fuji Velvia

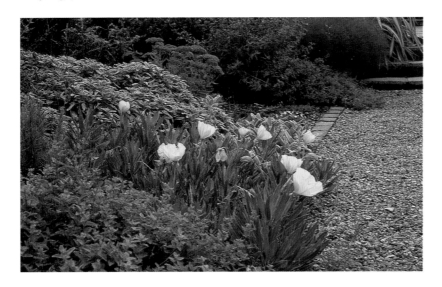

Bright yellow evening oenothera highlight a generous spillage of plants over the neat gravel path at Moverons in Essex, England.
28–80mm zoom lens, Fuji Velvia, tripod, 1/90sec at f/16

11

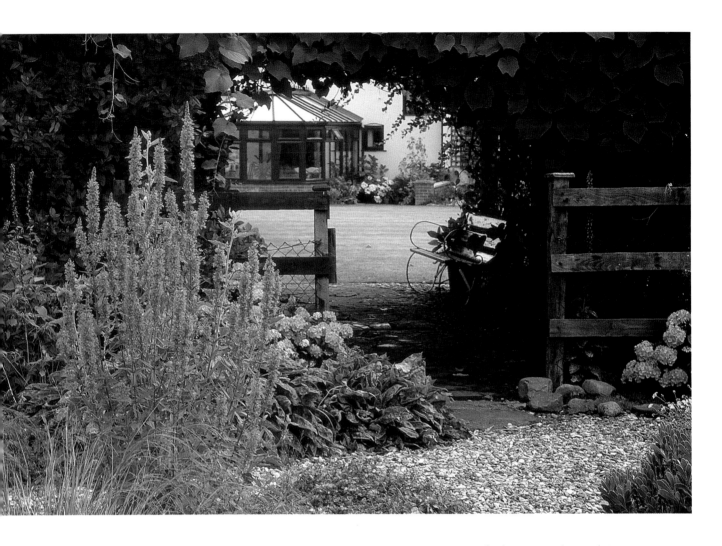

A dark tunnel of foliage reveals a view of the conservatory at Highfields Farm, Bures, England. The contrast between the areas of light and dark add interest and lead your eye through the picture.
28–80mm zoom lens, Fuji Velvia, tripod, 0.7sec at f/45

exciting images. As a source of photographic subjects, your own garden has the unbeatable advantage of being both close at hand and familiar. Also, you are likely to be aware of which areas are at their best at given times of the year or in a particular light. This intimate knowledge will be invaluable in helping you to create beautiful pictures.

Just as you will never create a beautiful garden purely by filling a space with expensive ornaments and fashionable plants, good garden photographs do not call for the most up-to-date cameras and costly accessories. Like gardening, photography depends on a fusion of art and science. A basic understanding of the principles of photography is necessary, but then you must develop that esoteric thing – 'the photographer's eye'. For that, as with gardening, you require patience and practice.

The vast majority of images in this book were taken with a Canon EOS 300 camera, an entry-level single-lens reflex camera, which has recently been replaced by Canon with their updated EOS 300v. This is designed for amateur rather than professional photographers, so taking similar photographs should not be beyond the capabilities of any interested reader.

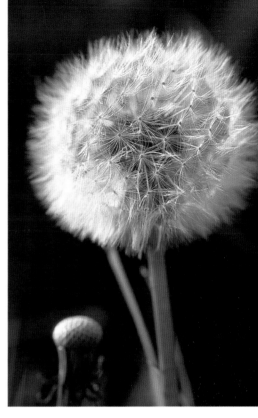

Even weeds can make interesting images. Here the seed head of a dandelion (*Taraxacum officinale*) glows in low-angled light.
Sigma 50mm macro lens, Fuji Astia, tripod, 1/2sec at f/22

If you enjoy growing plants from seed you will already be aware of the amazing variety in form between the different species. As a result of this, seeds can make an interesting subject on which to practise your skills in close-up photography.
Sigma 50mm macro lens, Fuji Astia, tripod, 1/4sec at f/45

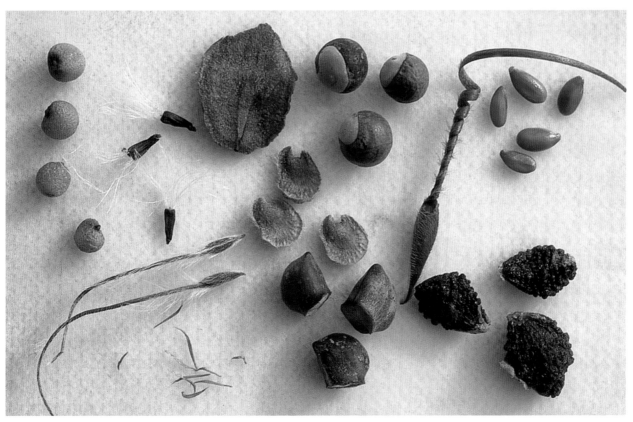

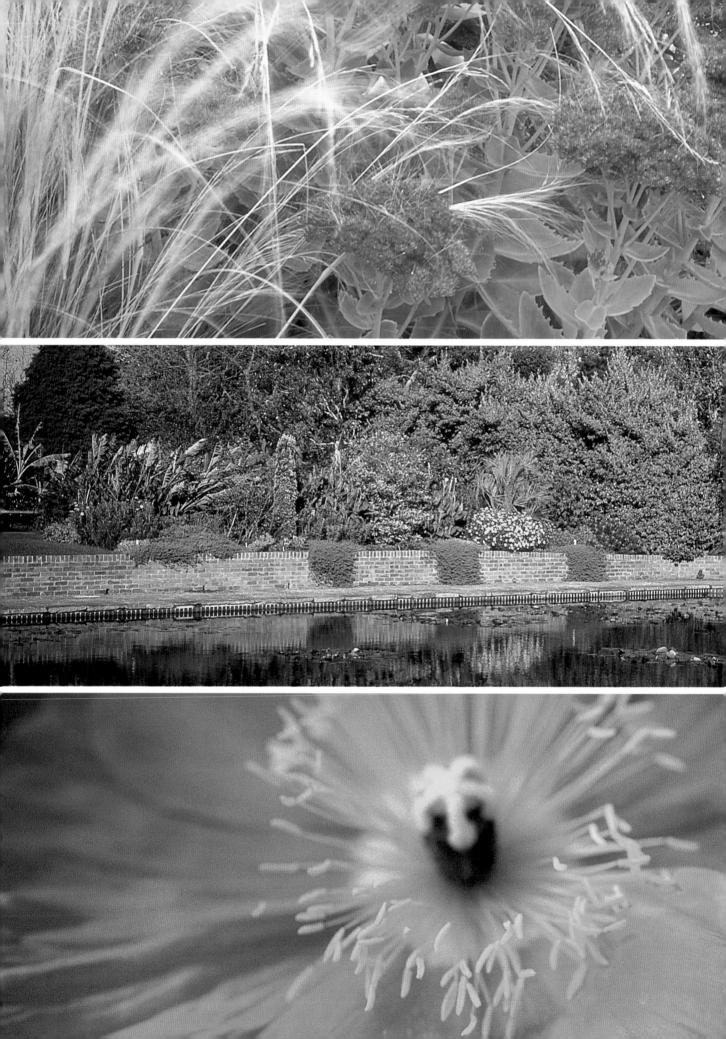

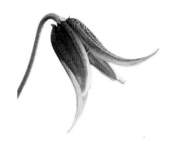

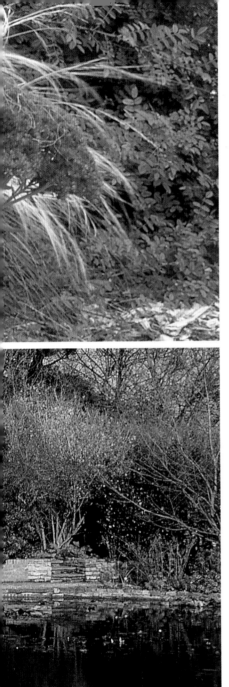

EQUIPMENT

1

THE CAMERA

CHOOSING A CAMERA.

35mm COMPACT CAMERAS.

APS CAMERAS.

35mm SLR CAMERAS.

MEDIUM-FORMAT CAMERAS.

DIGITAL CAMERAS.

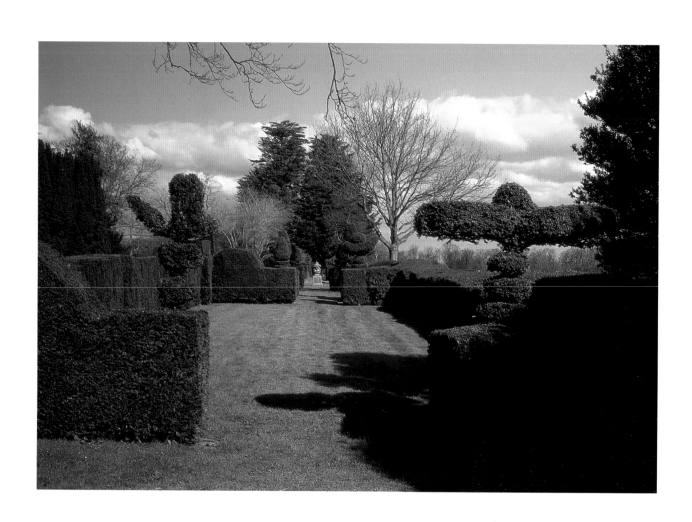

The first cameras were based on the idea of the camera obscura; an artist's tool dating from the Middle Ages, the name of which comes from the Latin for 'dark chamber'. This was basically a darkened room with a lens at one end. At the other end was a screen onto which an image was projected. An artist could trace off an image in order to achieve extreme realism in the resulting painting. Walking into a photography shop today and looking at the wide variety of cameras on offer can be a baffling experience; enough to deter any would-be photographer. However, even the most technologically advanced camera still works by focusing light onto a surface to form an image, just as the lens of your eye focuses light onto your retina. The amount of light can be altered by changing the size of the aperture – a hole through which the light passes – and also by changing the time that the shutter remains open to allow the light in. The camera body dictates the format of the resulting photograph, as most cameras only accept one size of film.

CHOOSING A CAMERA

When choosing a camera it is important to think first about what you want it for. A simple digital camera may be ideal if you aim to catalogue all the plants in your garden, as images can be downloaded onto your computer or viewed on a television screen. Someone wanting some colour prints of their own or other people's gardens may find that a 35mm or APS compact camera is perfect as it is easy to use and can be slipped into a pocket. For high-quality artistic images of a garden, a 35mm SLR camera may still be the best choice, although recent developments in technology mean that a digital SLR camera may now be a viable alternative.

My advice is to consider all the options, handle a selection of cameras and read a few of the current photography magazines. Some shops may let you have a trial run with a camera in return for a small deposit. If you have Internet access, typing 'camera reviews' into a search engine will produce a bewildering range of recommendations from the camera manufacturers, as well as professional photographer's websites and those of keen amateur camera buffs.

Opposite: Yew topiary casts strong shadows in the spring sunshine here at Saxham Hall in Suffolk, England. 28–80mm zoom lens, Fuji Velvia, polarizing filter and grey graduated filter, 0.7sec at f/27

Do not scorn second-hand equipment. Indeed, many professional photographers use it. However, I would not necessarily recommend buying from a professional photographer, as their equipment can often be rather battered.

35MM COMPACT CAMERAS

Compact cameras are very popular as they are small, portable and are designed to be easy to use. Some of the cheapest compact cameras have fixed focus. These have the advantages of being lightweight and inexpensive, and may be suitable for quick snapshot pictures, but are generally of limited use.

A disposable 35mm camera

35mm compact camera with
zoom lens

An autofocus camera, especially one with a zoom lens, permits much more creativity in your photography. A problem with most compact cameras is that the viewfinder is separate from the lens. As a result, what you see through the viewfinder is not identical to what will appear in your photograph. This 'parallax' error (see Glossary, page 170) is most noticeable when you are trying to get close portraits of flowers. Look out for cameras with real-image viewfinders to overcome this. If you want to take plant portraits, make sure that you choose a camera that can focus down to 20in (0.5m) or less.

APS CAMERAS

Advanced Photo System (APS) cameras were introduced in 1996. They share many features with 35mm compact cameras, but have drop-in film loading for ease of use. This will please anyone who has ever shot a set of once-in-a-lifetime pictures, only to discover that the film has not wound on correctly. Films have an ultra-fine grain giving good picture quality, and developing includes an index print to show the all images from a whole film at once, making ordering reprints and enlargements simple. The choice of picture format covers: Classic (C) 6 x 4in (15.2 x 10.2cm), High-Definition Tele-Vision (HDTV) 7 x 4in (17.8 x 10.2cm) and Panoramic (P) 10 x 4in (25.4 x 10.2cm). The panoramic format is probably the main selling point of the APS system for garden photographers, as wide garden views can be taken easily and at low cost using this option.

APS compact camera

In practice, this system offers few advantages over 35mm compact cameras, and the market is now declining due to competition from digital cameras. Minolta, one of the consortium of manufacturers who introduced the system, announced in December 2001 that they would stop making these cameras, investing instead in the digital arena.

35MM SLR CAMERAS

Single-lens reflex (SLR) cameras have one lens that exposes the image, and this is also used for viewing by means of a mirror positioned between the lens and a focusing screen. This system allows you to frame a picture without parallax error and helps to avoid the type of pictures in which the tops of heads are cut off. This is the type of camera usually chosen by the serious photographer as it is extremely versatile and allows greater levels of creativity. However, with the latest sophisticated autofocusing and automatic-metering systems, even a beginner can produce high-quality pictures using this type of camera. Autofocus models are of particular benefit for moving subjects, such as wildlife or action shots.

If you choose an autofocus SLR, it is worth opting for a model that also has a manual mode; as you gain experience, you may appreciate the greater control that this gives you in creating your pictures. Manual SLRs provide total freedom to choose everything from aperture to shutter speed. They are generally cheaper than autofocus models and are often chosen by those wanting to learn the essential principles of photography.

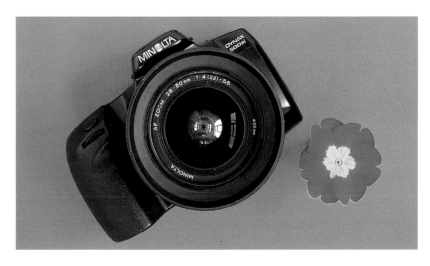

Single-lens reflex camera

Using a SLR camera with an autofocus setting can give good results even for beginners. My son, Ashley, took this close-up portrait of an Icelandic poppy (*Papaver nudicaule*) when he was eight. Using a hand-held camera required a fast shutter speed to prevent camera shake, and the resulting smaller aperture reduced the available depth of field.
28–80mm zoom lens, Fuji Astia
© *Ashley Harland*

A wide range of interchangeable lenses are available for SLR cameras. Choose a camera that will take lenses from one of the major manufacturers (Canon, Minolta, Nikon, Olympus and Pentax) in order to ensure that you will have the widest range of options.

MEDIUM-FORMAT CAMERAS

Medium-format cameras usually use 120 roll film, but different camera makes will give different sizes, commonly 6 x 6cm, 6 x 7cm or 6 x 4.5cm. These are substantially bigger than the 35mm format – an important consideration for anyone trying to sell their work, as the larger transparencies look more impressive on a light box and can be reproduced to a greater size without loss of sharpness. Medium-format cameras are, however, heavier and bulkier than 35mm SLRs, so even a professional photographer may prefer a 35mm camera

Medium-format camera

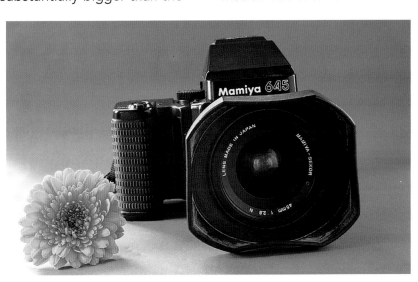

for field work. Some are also considerably more expensive, but if you require high-quality images they are hard to beat.

Large-format cameras are also available. These focus the image onto a screen directly behind the lens and use large individual sheets of film, which may be 10 x 8in (25 x 20.5cm), giving exceptional image quality. They are very cumbersome and so tend to be used just for studio work. Some landscape photographers swear by them because of the high degree of detail that can be recorded, but 5 x 4in (12.5 x 10cm) is really the largest practical format for outdoor work.

DIGITAL CAMERAS

Digital cameras convert the image they receive into electrical signals by means of a special light-sensitive chip called a charge-coupled device (CCD). This processes the picture into pixels and creates an image file. Generally, the higher the number of pixels a CCD can produce the better the quality of the resulting picture (and the more expensive the camera). The file can be read by a computer, which allows you to view the image on a monitor or print it out using a printer.

Digital camera

Images can be stored in the camera's internal memory (in the short term), or on removable memory cards or a computer's hard drive (in the long term). Photographs can be printed from the memory card by most photography stores or via the Internet. Home-printing options include plugging your digital camera directly into a photo printer, or going through the home computer. One of the advantages of digital cameras is that you can review your photographs, deleting those you do not want to keep so that you only have to pay for the prints you require. Remember, though, that to end up with a satisfactory picture you need to print onto good-quality photographic paper, which can be expensive.

Digital technology is advancing at a dramatic rate, so you will need to ask for advice on the latest developments. To produce high-quality prints up to A4 size, you probably need a digital camera that operates at an effective 4 million pixels (4 megapixels) or more; for quality A3 prints, over 6 megapixels. Digital SLR cameras are becoming popular and combine the best of the two systems, but are still very expensive.

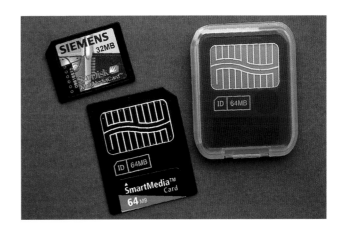

If you have a collection of prints or 35mm transparencies, they can be digitalized using a scanner. Flatbed scanners work much like photocopiers, and many of them have optional transparency adapters to convert 35mm slides and film into digital files. Film scanners – which generally give higher-quality results than flatbed scanners – are usually designed for scanning 35mm slides and negatives, but may have optional adapters for scanning APS.

There are a number of different memory cards available for use with digital cameras.

Choose a good-quality photo paper to optimize results if you are printing out digital photographs at home.

LENSES

WIDE-ANGLE LENSES.

THE STANDARD LENS.

TELEPHOTO LENSES.

MACRO LENSES.

LENS HOODS.

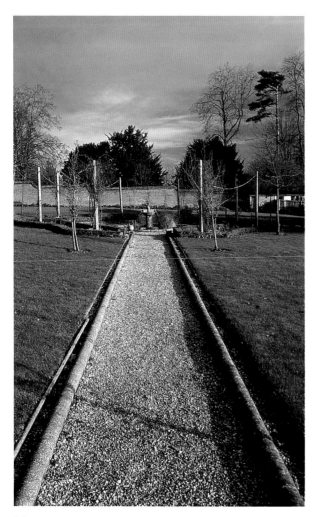

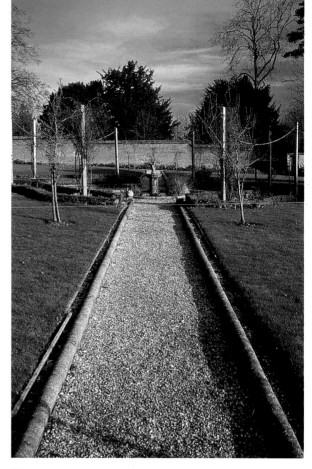

28mm

35mm

The main function of a lens is to focus light from the subject in order to create an image. To reduce distortions, a camera lens is made up of not one but several pieces of glass, called elements. These are coated with thin transparent layers to cut down on unwanted reflections within the lens.

Most SLR cameras used to be sold with a 50mm lens. This focal length is considered standard for 35mm cameras because it gives a perspective that most closely approximates to that of the

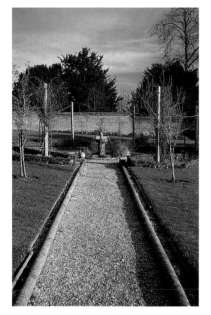

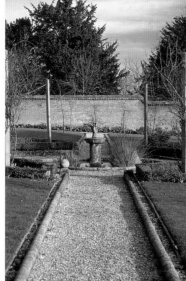

This page and facing: A series of pictures taken from a constant position. In the first image, which used a 28mm wide-angle lens, converging lines emphasize the length of the gravel path. As the focal length of the lens used increases, the image of the central statue is magnified, perspective is compressed and depth of field is reduced.
Fuji Provia (100 ISO), all at f/8

50mm

80mm

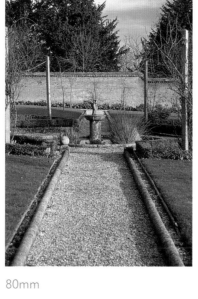

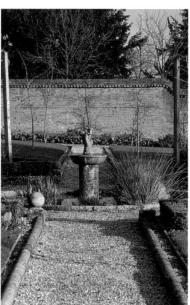

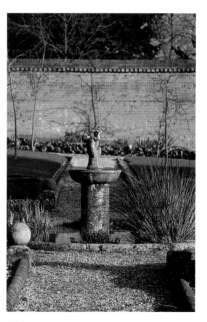

100mm

135mm

200mm

central field of vision of the human eye. The focal length is the distance between the optical centre of a lens and the point at which light rays from a distant object are in focus. The longer the focal length, the narrower the depth of field will be.

Lenses with a focal length longer than that of a 50mm lens usually called telephoto lenses; wide-angle lenses have a shorter focal length. A digital camera usually has a standard focal length of between 6mm and 8mm, which is equivalent to 40–60mm on a 35mm camera.

Today, most cameras are sold with a zoom lens, which provides a range of focal lengths, perhaps 28–80mm. A zoom lens is optically complex, with some 10 to 20 elements, which makes it heavier than an equivalent regular lens, but it can be used to replace perhaps 3 or 4 lenses of fixed focal length. Also, as the focal length can be altered continuously, it allows for very precise framing of an image.

WIDE-ANGLE LENSES

Wide-angle lenses are used to give expanded coverage of a scene, and are therefore ideal for garden views. If used at small apertures they can achieve a great depth of field, allowing both foreground interest and the background to be

Another view of the statue shows how using a wide-angle lens can exaggerate the size of foreground subjects. The built-in camera flash was used as fill-in flash to try to reduce the shadow on the statue.
28–80mm zoom lens,
Fuji Provia (100 ISO), polarizing filter, 1/30sec at f/9.5

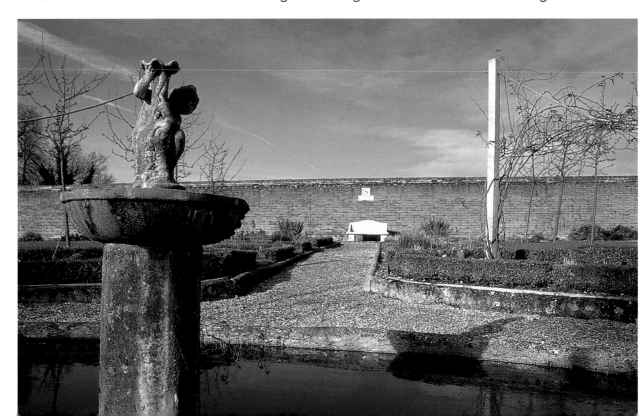

in sharp focus. They are an excellent tool when photographing in confined spaces as they give a broader field of view.

Lenses with a focal length of 24mm and below tend to introduce visible distortions to a picture, an effect that is exaggerated when the camera is tilted upwards. While this may perhaps be undesirable when photographing architectural features, it can be used to dramatic effect in emphasizing the height of a tree or other tall plant.

THE STANDARD LENS

The 'normal' lens, which for 35mm cameras is taken to be a lens with a focal length of 50mm (equivalent to 75–90mm for a medium-format camera), is relatively inexpensive to buy and has a high optical quality. It is ideal for photographing garden views without distortion or for pictures of plant groups. Most still-life photography uses the normal lens and, when used with an extension tube, the normal lens can double up as a macro lens for close-up shots.

TELEPHOTO LENSES

The most noticeable quality of a long-focus or telephoto lens is that it magnifies the image. For example, a 300mm lens magnifies the image by six times, as its focal length is six times as long as that of the standard 50mm lens. The longer the focal length, the more the image is magnified. Focal length may range from 80–800mm for a typical 35mm camera lens; the drawback being that as their focal length increases so does their length and weight. Using the longer telephoto lenses greatly increases the risk of camera shake; with very long lenses you may find that you need not just a tripod (see pages 42–3) for the camera, but also an additional support for the lens.

Telephoto lenses are ideal for situations where you cannot get close to your subject, whether it be timid wildlife or a feature on the other side of a lake. They appear to compress perspective, an effect that is much used to make a border appear packed with flowers. Their narrow field of view can be a useful quality, enabling you to pick out a small subject from a distracting background.

Apochromatic lenses are designed for increased image sharpness and colour rendition. They are more expensive than a standard telephoto or zoom lens, but are worth considering. Image-stabilization or vibration-reduction (VR) lenses, which use technology from the film industry, give greater stability when holding a camera by hand – lenses up to around 400mm can be hand held. This makes them an ideal choice for anyone who hates carrying around a tripod. Mirror lenses, sometimes called reflex or catadioptric lenses, use a combination of lenses and mirrors to bounce light back and forth within the lens, allowing a shorter, lighter lens than the comparable telephoto lens. They are also much cheaper. However, they have a fixed aperture, so there is no control over depth of field, and picture sharpness can be greatly reduced.

MACRO LENSES

A true macro lens is optically corrected to give the sharpest results at a very close range. It can focus accurately at least twice as close to a subject as a conventional lens of comparable focal length, and image quality is still good at conventional distances, so these lenses can also be used for general garden views. Macro lenses come in focal lengths of around 50–200mm, although the best all-round choice is probably a 90mm or 100mm lens, and have extended focusing mounts enabling the lens to be moved closer to the subject. Some makes are capable of life-size reproduction.

The shorter focal length of macro lenses requires you to work very close to your subject, and this can create some problems. For example, you must be careful to avoid getting your shadow in the frame. Doubling the focal length of the lens doubles the working distance from the subject, which may help to solve this problem. Also, at close focusing distances the depth of field is greatly reduced. To keep your image sharp, try to ensure that the camera is parallel to your subject and use a very small aperture. Macro lenses usually have a very small minimum aperture of f/32 or f/45. Camera shake will be very apparent at close distances, so always use a tripod.

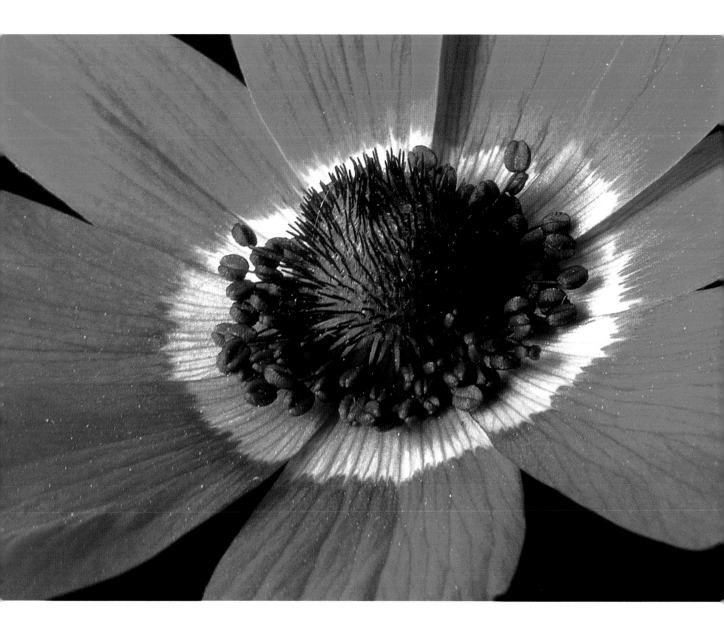

LENS HOODS

A lens hood is an important item, especially when photographing against the light. It shades the lens, increasing colour saturation and shadow detail in the image and reducing the risk of flare from stray light. It also offers the lens protection from knocks and scratches, and is much cheaper to replace than the lens itself. Lens hoods are of particular importance for wide-angle lenses, which require a specifically designed hood to prevent vignetting (black corners on your pictures where the lens hood has encroached into view).

Using a macro lens allows you to get really close to your subject, giving sharp results and lots of detail, as in this flower of *Anemone pavonina*.
Sigma 50mm macro lens, Fuji Astia, tripod, 1/8sec at f/45

LIGHT METERS AND FLASH

TTL METERING.

HAND-HELD METERS.

FLASH.

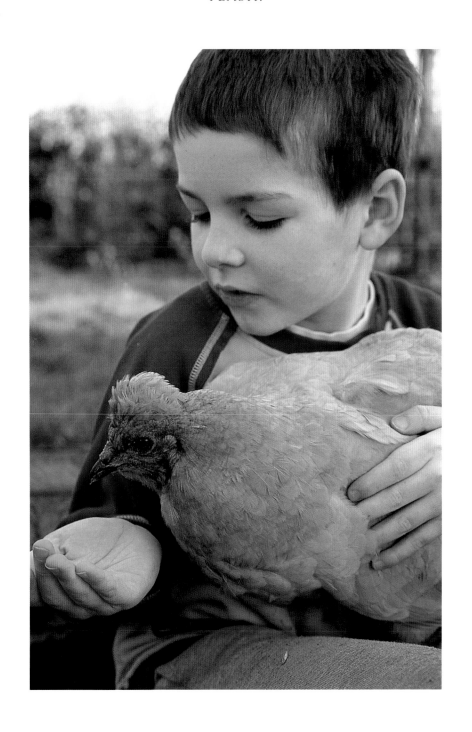

TTL METERING

Most modern SLR cameras have a built-in exposure meter that measures the light entering the camera through the lens. According to the make of camera, there may be different modes of this 'through-the-lens' (TTL) metering. Evaluative/matrix metering is the standard metering mode and measures the light reflected into the lens from the whole of the scene. Partial metering is used particularly for backlit subjects, and its assessment of light is based on the brightness of an area (of around 10% of the frame) at the centre of the viewfinder screen. Centre-weighted (averaging) metering measures the entire scene, but places a greater emphasis on the central portion. Spot metering measures just a small portion, perhaps 1–2% of the scene, which can be useful if you want to photograph a small subject against a contrasting background.

As TTL metering measures the light entering the camera, it will automatically record changes in lighting conditions and angle of view, and adjust to situations in which you are using an extension tube or lens filter. With autofocus cameras, the meter is linked directly to the camera's controls so that aperture and/or shutter speed can be set automatically. A drawback with this system is that automatic cameras are designed for average lighting conditions and assume that the photographer will compose the picture in the centre of the viewfinder. Experience will show you how your camera's metering system will cope with unusual lighting conditions, particularly high-contrast situations.

HAND-HELD METERS

A hand-held light meter allows you to take different types of light measurement to supplement the reflected-light readings of your camera's TTL system. The hand-held meter is used primarily for its ability to read incident light (i.e. the light that falls on a subject rather than that reflected by it). Incident light is not affected by the colour of the subject, and its measurement can be a useful exposure check in difficult metering circumstances. Many meters have a built-in memory to permit recall of different areas of light and shade and the average data for a given scene.

Opposite: Our lavender Araucana chickens make a good impromptu substitute for photographic grey card (a sheet of grey card which reflects a standard 18% of the ambient light falling on it) if I want a neutral-toned subject to check exposure values in a high-contrast situation. *80–200mm zoom lens, Fuji Provia (100 ISO), tripod, 1/30sec at f/11*

A photographic grey card (a sheet of grey card which reflects a standard 18% of the ambient light falling on it) is useful for neutral reflected-light meter readings. Place the card in front of your subject and take a light reading from it. Alternatively, you could use any other neutral-coloured item. Some photographers go to the extent of making sure they wear a grey coat when working so that they can take a light measurement from their sleeve.

FLASH

Like many garden photographers, I always prefer to work with natural light. However, there are times when the use of electronic flash is beneficial or even essential. In shady conditions the use of flash may be necessary, especially when using a slow film. On a breezy day, a short burst of flash will freeze the motion of a wind-tossed flower. In bright sunshine, flash will soften harsh shadows and boost ambient light levels, enabling small apertures to be used. Portraits of flowers taken with flash tend to give a dark background, which may be useful to isolate the subject from surrounding distractions. Flash can also act in the same way as a reflector to provide fill-in light, revealing details in foreground subjects.

Many cameras have their own built-in flash, which can be used for distances of perhaps 3–30ft (1–10m), depending on lens/film used. These flashes give the best results with highly coloured subjects, but can often give disappointing results as the flash is so close to the lens. Harsh light can make pictures look very flat and it is important to keep the flash unit (or camera, if using built-in flash) at least 3ft (1m) away from the subject. An additional problem when using flash with wide-angle lenses is that the periphery of the photograph may look dark.

Portable flash units are designed to be small and easily used. They can fit either into the standard 'hot shoe' (see Glossary, page 169) on your camera or can be used off-camera when connected by cable. Choose a unit with a swivelling head so that it can be used to bounce the light off a reflector or ceiling to provide a more natural effect. With a manual flash unit you choose the level of flash needed; automatic models

make this decision for you. Dedicated flash units have contacts to the exposure control system of the camera so that the camera assesses how much light is needed for each photograph. The guide number, for example 28M, gives an indication of the power and shooting distance of a flash unit, in this case 85ft (28m) at ISO 100.

Mains flash units are often used for studio work. The flash tubes are larger and provide a more powerful light burst of longer duration. Additional flashes may be used to lighten dark backgrounds, and when more than one flash is used they may be linked with external cables or by using a 'slave unit', which is a photoelectric trigger.

For close-up work, ring flashes are available, which fit around your lens and provide bright, shadowless light. This lack of shadow can, however, make the image look flat.

These two images of a bantam cockerel show the benefits of using flash outdoors to reduce contrast in backlit situations and to fill in foreground details. *80–200mm zoom lens, Fuji Velvia, 1/60sec at f/5.6*

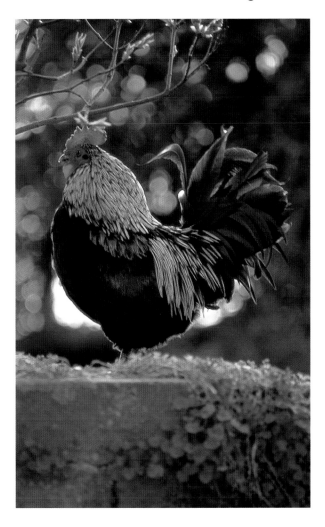

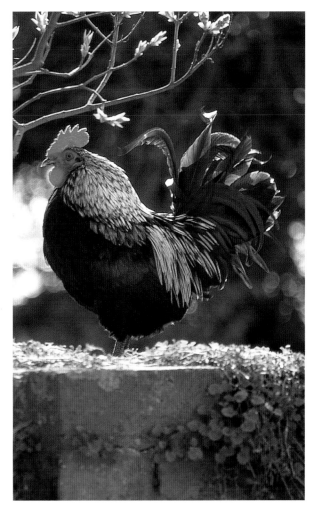

FILM

COLOUR PRINT AND TRANSPARENCY FILM.

BLACK-AND-WHITE FILM.

SPECIALIST FILMS.

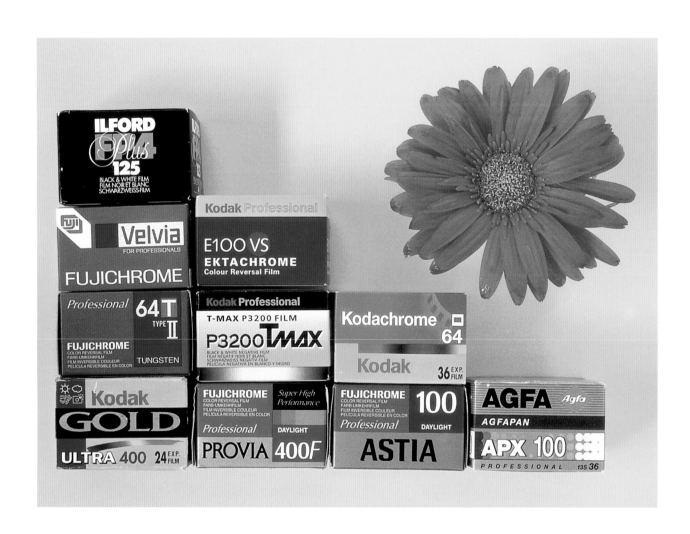

There is a wide range of film available in different formats, speeds and colours. Choice
is very much down to personal preference.

A hundred years after the German doctor Johann Schulze discovered, in 1727, that silver nitrate darkens when exposed to light, the first photograph was taken by Joseph Nicéphore Niepce, who focused light from his window onto a pewter sheet coated with light-sensitive bitumen. Modern photographic film consists of a flexible plastic base, coated with gelatin emulsion, in which light-sensitive silver halide grains of varying sizes are embedded. The coarser the grains, the faster they react to light and therefore the 'faster' the film.

COLOUR PRINT AND TRANSPARENCY FILM

Negative films are used for making prints, and so are ideal for those wanting pictures to put in an album. They may be processed rapidly and inexpensively in a high-street laboratory, and reasonable results can be obtained without great accuracy in exposure. Reversal films produce transparencies, which when mounted are known as slides. This type of film is used for projection (although digital projectors are also made and are becoming more widely available), and is demanded by publishers for reproduction in books and magazines. Accuracy in exposure is more critical with this type of film, but it produces a sharper image and richer colours.

Both types of film are available in a range of speeds relating to their sensitivity to light. Film speed is measured using the ISO (International Standards Organization) scale. Slow films have an ISO of 100 or lower; a fast film is one over ISO 400. The scale is easy to follow, and ISO 200 films are twice as sensitive to light as ISO 100 films. Slower films can be used to record more detail, as they develop finer silver grains when exposed. However, they require longer exposure times, so there is an increased risk of getting a blurred image due to camera shake. In poor light it is essential to use a tripod with slow films.

Fast films are a better choice for a hand-held camera. With wildlife/human subjects, or even plants on a breezy day, film of ISO 200 or more may be needed to permit a shutter speed fast enough to freeze subject motion. Fast colour films rarely

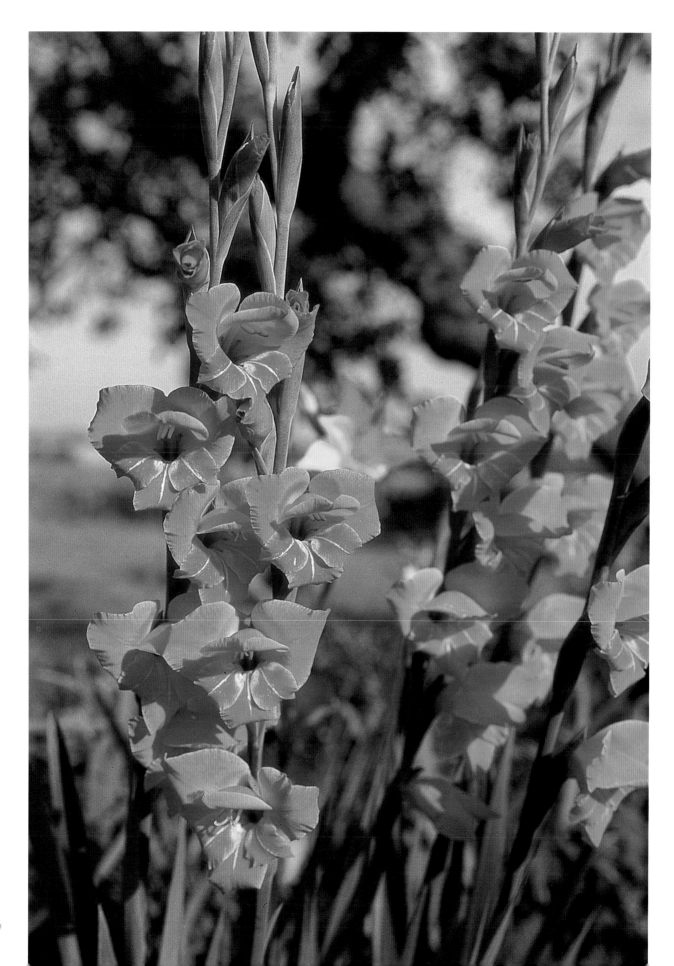

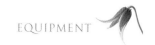

give totally accurate colours, and, when enlarged, pictures are often grainy. The grainy texture of faster film may sometimes be considered beneficial, adding to the mood of portrait or landscape shots.

Different makes of film, even when they are of the same type and speed, will not record colours in an identical way. Fuji Velvia (ISO 50) is renowned for the vibrancy of colour it produces, but some people find that the colours, particularly the greens of foliage, look artificially bright. Kodachrome 64 renders colour in a more natural way, but images taken in overcast conditions can look dull. I find Fuji Astia (ISO 100) particularly good for recording blues, which many other makes of film do not reproduce well. Film choice is really a matter of taste; it is worth trying out several makes and getting to know their characteristics.

Opposite: For vibrant colours, as in these spikes of Gladiolus 'Robinetta', Fuji Velvia transparency film is a popular choice.
28–80mm zoom lens, Fuji Velvia, tripod, 1/45sec at f/22

Fuji Astia gives particularly good colour reproductions of blues and greens, which can look a little artificial with Velvia film.
Sigma 50mm macro lens, Fuji Astia, tripod, 0.7sec at f/16

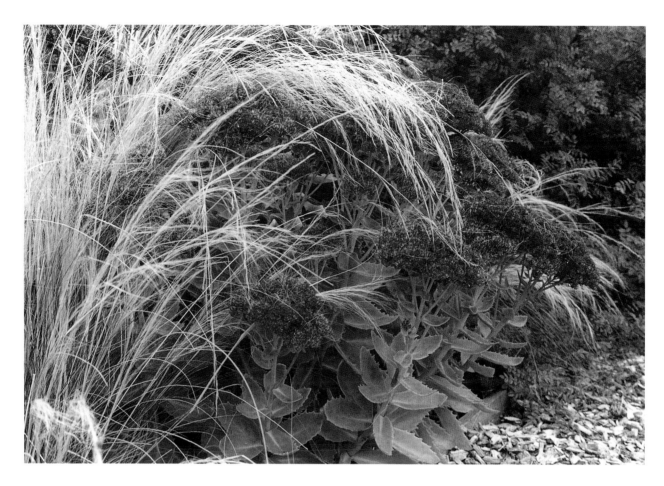

Using a black-and-white film for this grouping of stipa grass, sedum and rose foliage encourages the eye to concentrate attention on the different textures.
Sigma 50mm macro lens, Agfapan APX (100 ISO), tripod, 1/10sec at f/11

BLACK-AND-WHITE FILM

Even though the impact of colour could perhaps be considered essential in garden photography, it is worth experimenting with black-and-white film, which often produces more abstract pictures, concentrating the eye on details of shape and texture. There are times when colour may be a distraction, leading the eye away from a strong composition or the depiction of texture. It does require experience to judge how well a subject will look in shades of grey, and strong side lighting is particularly beneficial in creating contrast.

SPECIALIST FILMS

Specialist films include tungsten-balanced film, which will record colours under artificial light accurately (ordinary daylight-balanced film give tungsten-lit conditions an orange cast). This may be a useful film to have in your camera bag if you plan to take pictures at a flower show.

When the same picture is taken with colour film it is the russet tones of the sedum and the blonde grass that attracts attention.
Sigma 50mm macro lens, tripod, Fuji Velvia, 1/3sec at f/16

Black-and-white film is available at very fast speeds, which give a noticeably grainy effect. This has been exploited to produce an eerie mood in this picture taken at the Plantation Garden in Norwich, England.
28–80mm zoom lens, Kodak P3200 Tmax, grey net filter, 1/250sec at f/11

ACCESSORIES

CLOSE-UP ACCESSORIES.

CAMERA SUPPORTS.

REFLECTORS AND DIFFUSERS.

FILTERS.

SELF-TIMERS AND REMOTE RELEASE.

CAMERA BAGS.

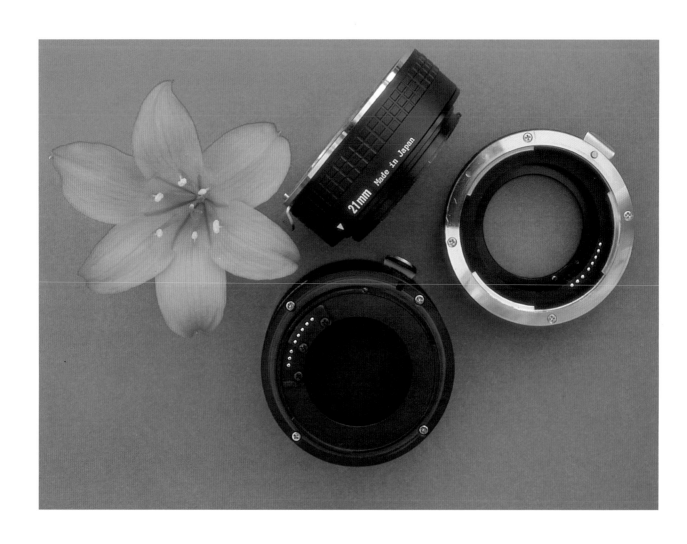

CLOSE-UP ACCESSORIES

A close-up lens – a single-element lens that fits in the filter mount in front of your normal lens – is the cheapest and easiest way to practise close-up photography. Close-up lenses are available in different strengths ranging from +1 to +4 dioptre (the unit of measurement used to denote magnifying power), with +4 being the strongest. Two lenses can be used together, the strongest being mounted first, but with powers greater than +4 there will be a deterioration in image sharpness. This loss of sharpness can be counteracted to some degree by using small apertures.

Close-up lenses are generally designed for use with standard 50mm lenses, rather than with zoom lenses. They do not give as good results as you would get when using a macro lens, but they are inexpensive and easy to use. Unlike extension tubes, they do not tend to reduce the amount of light reaching the film, so they will not affect exposure times.

Extension tubes work by increasing the distance between the lens and the film plane. They are usually sold in sets of three, which can be used in combination. The make that I use has tubes of 13mm, 21mm and 31mm. 50mm of extension tubes, when used with a 50mm standard lens, will allow life-size (1:1 ratio) reproduction, so my set of tubes combined is able to provide over 1:1 reproduction. However, when using high reproduction ratios in this way, the working distance between the end of the lens and the subject is small, around 50mm, which gives very little room for manoeuvre. The built-in focusing of the lens is ineffective at this range, so you need to move the camera back and forth physically. Longer exposures will be needed because of the extra distance the light must travel to reach the film.

Despite these drawbacks, extension tubes are often used for close-up work, and are excellent if you want to take a portrait of a small flower such as a snowdrop. The shorter, 13mm, tube is also useful if you want to reduce the minimum focusing distance of a telephoto lens.

Opposite: Extension tubes are usually available in sets of three. This range includes tubes of 13, 21 and 31mm. Used together they allow reproduction ratios in excess of 1:1.

Reversing rings are adaptors that allow wide-angle and standard 50mm lenses to be mounted back to front for close-up work. Obviously, the automatic exposure control couplings between lens and camera are lost when the lens is reversed, so a special adaptor called a Z-ring is used to restore control. A double cable release is used to stop down the lens aperture and release the shutter. A reversed standard lens will give a reproduction ratio of 1:2; a reversed 25mm wide-angle lens gives a ratio of 3:1, which is useful for revealing the tiny details of a plant.

CAMERA SUPPORTS

One of the key ways of improving the quality of your pictures is to use a tripod. By doing so you dramatically reduce camera shake, enabling the use of slower films and longer exposure times. Indeed, a tripod is essential in low light conditions, for precise close-up work, when using small apertures, and for heavy medium- or large-format cameras. Working with a tripod also has the effect of slowing you down, which helps you to concentrate on composition and makes photography a more deliberate, thoughtful process.

Choosing a cheap tripod is probably a false economy; go for one with sturdy tubular legs and sufficient extension height to enable you to mount a camera at eye level. Some tripods incorporate a spirit level to help with levelling. It is helpful to have a reversing central column, so that the camera can be used beneath the tripod for ground-level shots, perhaps of alpine plants. If used in this way you need to have a tripod head that allows the camera to be used the right way up, or you will have to stand on your head to use the camera controls (a right-angle viewing attachment saves a lot of lying on the ground squinting through the lens).

Tripod heads come in two styles: the ball-and-socket head is quicker to use but can sometimes be difficult to level; the pan-and-tilt head will lock up tighter and has a larger base for the camera, making it essential for heavy medium-format cameras.

When using a tripod, make sure it is on stable ground. Adjust the legs to level the platform rather than relying on levelling

the head itself. In windy conditions you can increase the stability of the tripod by suspending a weight (for example, your camera bag) from the centre of the tripod.

Monopods are, not surprisingly, one-legged tripods. They offer less stability than a tripod, but are sometimes used because they are lightweight and highly portable.

A more basic form of camera support is to make use of any suitable wall or bench to rest the camera on, but obviously this limits your choice of viewpoints. Uneven supports such as tree stumps can be used with the aid of a beanbag, which will accommodate the shape of the support and your camera. Some photography shops sell beanbags or you could make your own. Polystyrene beads make a lighter filling than rice or beans (and are washable). A beanbag is often easier to use than a tripod when working at ground level.

REFLECTORS AND DIFFUSERS

A reflector can be any surface that is used to reflect light towards your subject; a diffuser is a material through which transmitted light is scattered, and which has the effect of softening the light. Both reflectors and diffusers are useful tools in helping you to control the light falling on your subject.

A reflector can be something as basic as a handkerchief, a piece of white card, some aluminium foil or a mirror. A manufactured photographic reflector is usually a lightweight and collapsible circle, which may be surfaced in white, silver or gold. Ideally, it should be at least as large as your subject. Some are double-sided to give you a choice of surface. A gold surface reflects a warm diffuse light, whereas silver gives a brighter, rather harsh effect. White is probably the best choice for most situations.

A reflector is most useful in low light or high contrast situations. It is placed on the opposite side of the subject from the main light source, bouncing light into the shadowed areas. The effect of angling the reflector is easily visible, but it is often useful to have an assistant to hold the reflector for you.

In light scenes with high contrast levels, a reflector can help to make foreground subjects recognizable rather than silhouetted. To mimic soft light in a studio setting you can bounce electronic flash off a large white reflector placed above your subject.

The harsh lighting of bright sunlight casts dark shadows with distinct edges to them that can be very intrusive in a photograph. Sometimes the answer is to wait for more suitable weather conditions; clouds act as giant diffusers, scattering the light. However, for small subjects you can use an artificial diffuser (a piece of cloth such as muslin, or a sheet of translucent acrylic) placed between the sun and your subject to reduce contrast and eliminate heavy shadow. Diffusers are also useful if you are using a flash. Passing light through a diffuser increases the area of the light source and so decreases its intensity. Flash fired directly through a diffuser will provide a softer, more even, shadowless light. For small flash units, you can use tracing paper or lens tissue held over the flash, or alternatively you can buy translucent plastic attachments.

FILTERS

Filters are sheets of glass, plastic or gelatin that can be attached to the lens in order to modify the light reaching the film. For the most widely used types, circular filters are available in different sizes that screw in front of the lens. Alternatively, you can buy an oversize grooved plastic holder that accepts a range of filters. The second option has the advantages that the individual filters are cheaper, and that you only need to buy an adapter for each lens you use, rather than a set of filters. Do not be tempted to buy lots of filters straight away; the most useful are the UV or skylight filter, a polarizer, an amber warm-up filter and a neutral-density filter.

The digital manipulation of an image can replace the effects of using a filters, although it is often quicker to just slip a filter in front of your lens than to start altering images electronically. While most filters are designed to be used with SLR cameras, there are holders available that fit into the tripod bush of a camera so that they can then be used with digital or compact

cameras. Be careful when using a wide-angle lens to ensure that the edges of your filter holder do not cause vignetting. Also, make sure that filters are kept clean, or they may cause flare.

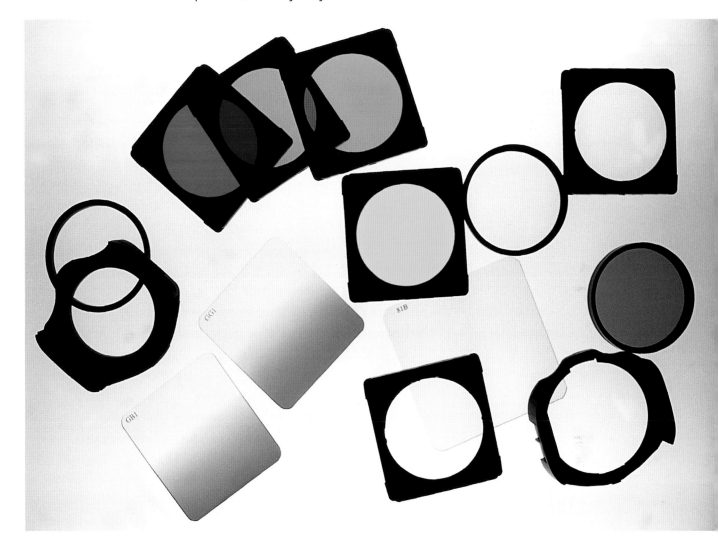

ULTRAVIOLET AND SKYLIGHT FILTERS

These absorb ultraviolet light and are used with black-and-white and colour films to reduce haze. They can make blues appear purer but have no discernible effect in other circumstances, so it is often recommended that they are left on permanently to protect your lens from scratches. However, some people feel that the extra layer of glass increases the likelihood of flare, especially when photographing into the light. I keep one on my 28-80mm zoom lens all the time, which is the lens I usually take if garden visiting. The filter has taken some scratches, and is cheaper to replace than the lens itself.

There are hundreds of filters available, but do not be in too much of a rush to buy them all; you may find that you use only a few of them regularly.

POLARIZING FILTERS

A polarizing filter reduces haze, cuts down on reflections from water and shiny surfaces by enhancing colours, and can deepen the blue of skies. It will not, unfortunately, add blue to a sky that is determinedly grey. In strong sunlight it acts like Polaroid sunglasses, reducing glare, lowering contrast and improving colour saturation. When used at midday, in intense light, the results may be too blue. If you find this to be a problem, the filters can be used in conjunction with a warm-up filter. These decrease the amount of light reaching the film by about two stops. The effect of a polarizing filter is greatest when photographing at right angles to the sun, and can be altered by rotating the filter in its mount. Linear polarizers are sold for manual-focus cameras; circular polarizers for autofocus.

NEUTRAL-DENSITY FILTERS

These reduce the amount of light reaching the film but absorb all colours equally, so they have no effect on the colour balance. They are used to allow slower shutter speeds or wider lens apertures in bright light situations or where a fast film is being used. By selecting a wider aperture, depth of field is reduced, allowing you to throw a distracting background out of focus. If you want to blur water or a moving object in bright conditions, fitting a neutral-density filter cuts the light reaching the film and allows you to set a shutter speed two or more stops slower than normal.

Graduated neutral-density filters decrease the brightness towards one half of the picture area, and are very useful to reduce extremes of contrast between the foreground and the sky in garden views. If you have a depth-of-field preview button on your camera, stopping down the aperture enables you to position the filter's transition line to suit your requirements. The most useful graduated filter is probably the

A light-grey graduated filter was used to even out the light levels in this view across the pond at the Royal Horticultural Society's garden Hyde Hall in Essex, England.
28–80mm zoom lens,
Fuji Velvia, grey graduated filter,
1/60sec at f/6.7

grey graduated, but you can get other colours, such as a red graduated, which could be used to enhance sunsets.

COLOUR-CORRECTION FILTERS

These are generally used to improve the accuracy of colours recorded on film, and are more important for colour

An amber warm-up filter (81B) and Fuji Velvia film were used to intensify the rich colours of these autumn leaves on an overcast day.

Sigma macro lens, Fuji Velvia, tripod, 81B filter, 3secs at f/22

transparency film. In dull weather, shade or under a leaf canopy some colour films give a bluish cast. Amber-coloured warming filters (81A, B or C) are used in these situations to restore the proper colour balance.

Strong sunsets cast a warm glow which most of us appreciate, but which can affect the colours of flowers. To restore true colours, a pale-blue filter (82A or B) can be used. Some blue flowers, notably clematis, can appear pink on film; the use of a pale-blue filter will correct this, but remember there will be a blue cast to the whole image, so it is best used when you are filling the viewfinder with the flower.

COLOUR-CONTRAST FILTERS

These are used with black-and-white film to emphasize certain colours. A coloured filter transmits light of its own colour and cuts other colours, so an orange filter used in autumn will enhance yellow-brown foliage tones; a green filter will brighten the colour of green foliage. Most useful is probably the yellow contrast filter (Wratten number 8), which reduces haze, deepens the colour of the sky, and makes clouds stand out. Red and orange filters have similar, though more pronounced, effects.

These strongly coloured filters can also be used with colour film to create unusual effects. If you are confronted with a dull, colourless scene, try experimenting with a colour-contrast filter to transform the look of your picture. If you are filling the frame with green foliage, adding a green filter will intensify the colour. Similarly, use of a yellow filter would enrich the colour of a field of sunflowers or oil-seed rape.

SELF-TIMERS AND REMOTE RELEASE

However carefully you press the shutter of your camera when taking a picture, it is inevitable that you will impart some vibration. Self-timers, which perhaps should have been discussed in the section on cameras as they are integral to the camera, are invaluable in allowing you to set up a shot and

then set the camera to fire the shutter. An alternative is using a cable release, which will significantly reduce the risk of camera shake, and is particularly important during slow exposures and in close-up work.

Mechanical cable releases are flexible cables that screw into a socket on the camera or lens. Electronic cable releases attach to the camera by means of electrical contacts. Short releases of perhaps 25cm (10in) are fine for most garden photography, but for taking pictures of garden wildlife a longer cable or an infra-red remote control, available for certain cameras, permits you to be further away from your subject. (Being too far back may not necessarily be a good thing; previously, our garden robin has casually perched actually on my camera, which makes taking its picture rather difficult.)

CAMERA BAGS

If your photographs are only ever taken in your own garden, having a special camera bag is probably of no great importance. However, if you like to get out and about it is undoubtedly useful to have a specific bag in which to keep all your photographic paraphernalia. You can of course use an ordinary handbag or rucksack, but for more protection it is probably wise to go for a purpose-made camera bag. Traditional bags are styled like a Gladstone bag with pockets, but more popular now are backpacks, which may feature lumbar support and adjustable sternum straps for those who plan on carrying a lot of gear over long distances. Smaller, holster-type bags, which fit onto your belt, are ideal if you just want to carry your camera and a couple of spare films.

A generous layer of padding protects your expensive equipment and adjustable internal sections mean that you can organize lenses, spare films, batteries and other gear to suit your requirements. An integrated tripod holder is also useful. Choose a bag that is waterproof so that you do not have to panic if you get caught in a sudden downpour. Do not use your camera bag for other items, such as food. I once used mine to stash some chocolate, which melted; weeks later, I was still picking it out of my camera.

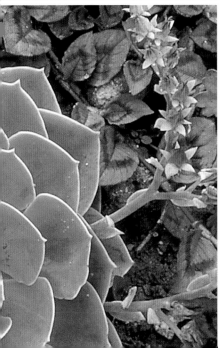

USING THE EQUIPMENT

2

Photographing
your garden

COMPOSITION

VIEWPOINTS AND PERSPECTIVE.

FRAMING THE PICTURE.

LOOKING FOR SHAPE, PATTERN AND COLOUR.

DEPTH OF FIELD AND FOCUSING.

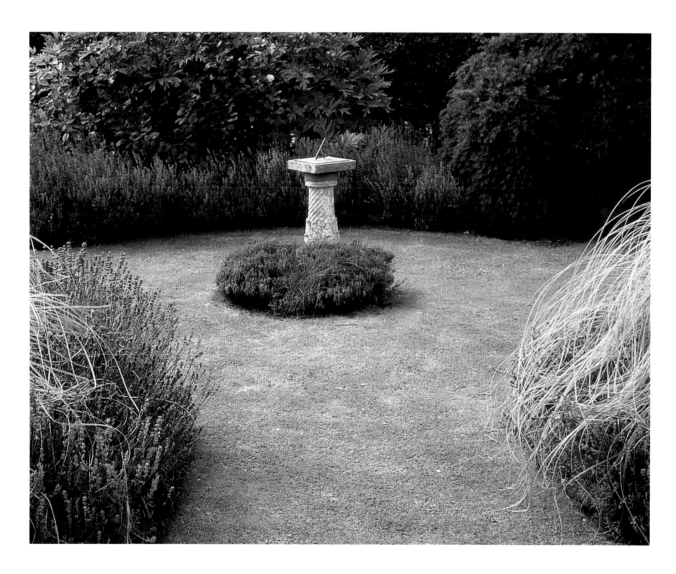

The central sundial in this part of the garden, with clumps of grasses flanking the entrance, forms a naturally composed picture.

28–80mm zoom lens, Fuji Astia, 1/60sec at f/11

Even the most expensive, technologically advanced camera cannot take pictures on its own. It is your skill and artistry in choosing the subject and arranging the image in the viewfinder that is essential in creating a masterly photograph. In the same way as a landscape painter selects a portion of the scene before him to paint, the photographer chooses what to include and, as importantly, what to exclude from his image. An attractive garden view or striking flower may 'cry out' to be photographed, but it is important to consider less appealing things – the washing line perhaps – that may lurk in the background.

VIEWPOINTS AND PERSPECTIVE

To obtain a satisfying picture, you need to choose your viewpoint with care. Moving around your chosen subject while looking through the viewfinder allows you to select the best

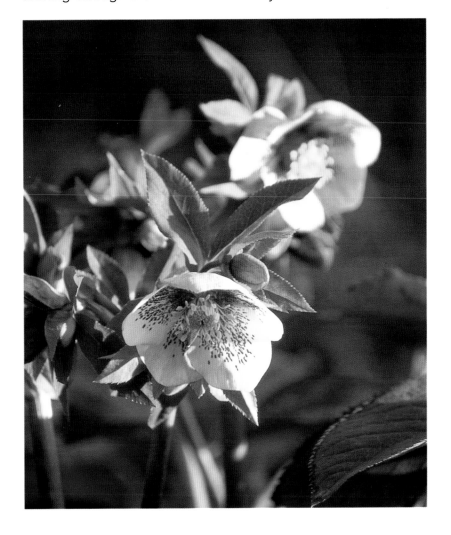

A low viewpoint, even if it means lying on the ground, enables you to look up into nodding flowers. Here, this reveals the attractive spots in these hybrid hellebores.
28–80mm zoom lens,
Fuji Provia (100 ISO),
tripod, 1/125sec at f/9.5

position to exclude distractions and provide an appropriate background for your subject. Holding the camera at eye level may seem more natural, but will not necessarily produce the most exciting images. Consider crouching or lying down to allow more of a distant background to be seen or to compose trees against the sky.

A high viewpoint may allow you to exclude a boring fence or reveal the intricacies of a parterre. Standing over a subject and pointing the camera down is also useful if you want to capture the detail of a mossy path or a section of carpet bedding. For larger subjects, make use of a bench, house window, balcony or even a nearby hilltop to obtain a high viewpoint.

Arranging the tripod directly over these echeveria and pointing the camera downwards gives an ideal view of this tapestry-like effect.
Sigma 50mm macro lens,
Fuji Velvia, tripod, 3secs at f/45

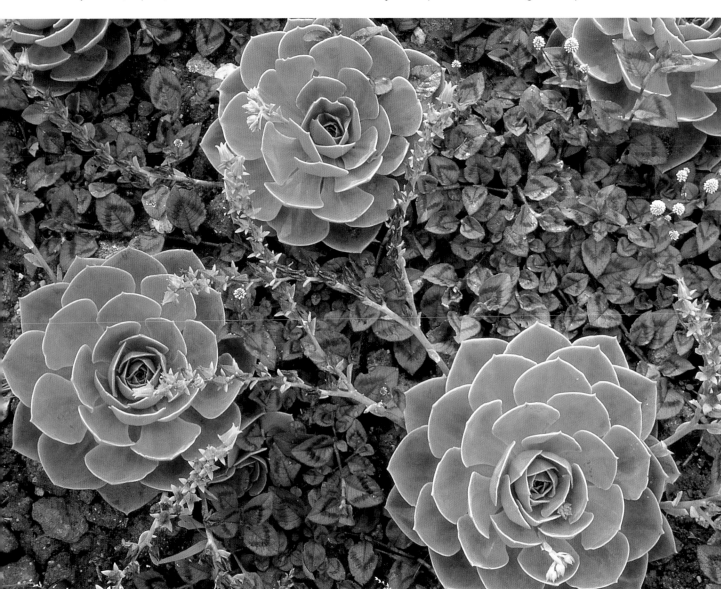

Perspective (the impression of distance and of the relative size and positions of objects) changes as your viewpoint changes.

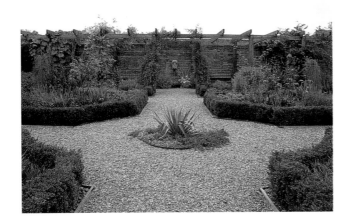

A wide-angle lens used to photograph the walled garden at Moverons in Essex, England, gives a full view, but the dull sky rather detracts from the picture.
28–80mm zoom lens at 28mm, Fuji Velvia, 1/3sec at f/22

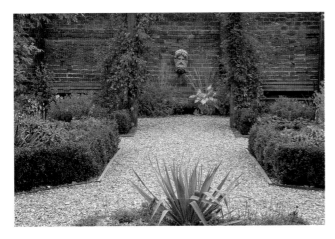

Using the 80mm end of the same lens magnifies the image and eliminates the sky from the picture.
28–80mm zoom lens, Fuji Velvia, 1/3sec at f22

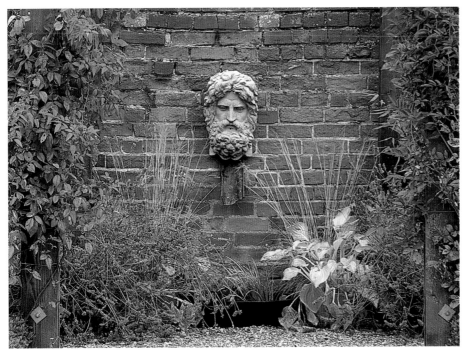

Changing to a longer telephoto lens enables you to zoom in on the mask on the wall and compresses the surrounding planting.
80–200mm zoom lens, Fuji Velvia, 1/2sec at f/22

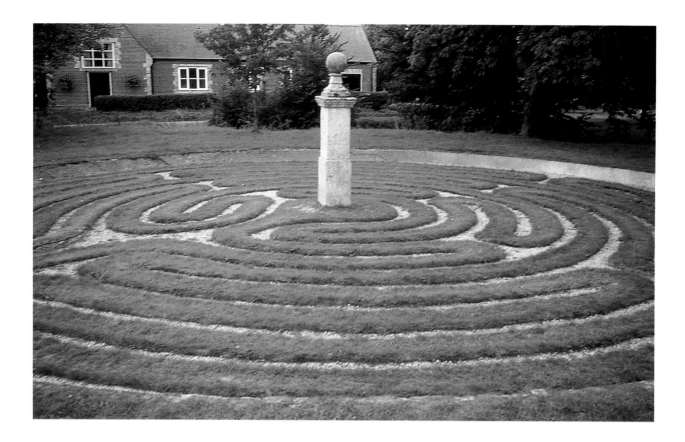

To attempt to capture the pattern of this turf maze at Hilton in Cambridgeshire, England, I balanced rather precariously on the arm of a bench. A fast shutter speed was required to try to minimize camera shake.
28–80mm zoom lens,
Fuji Astia, 1/180sec at f/4

Some garden designers use tricks of perspective to alter how the visitor perceives a garden; for example, subtly decreasing the width of a path to make it appear longer, or planting small-leaved plants behind those with larger leaves to increase the apparent depth of a border. With photography it is equally possible to deceive the eye. A wide-angle lens expands perspective, and using such a lens to photograph a flower border will emphasize depth, making the nearest flowers appear larger. Alternatively, a telephoto lens will compress perspective, making the border seem more densely packed.

FRAMING THE PICTURE

Considering how much of a scene you want to include within the frame of your picture will influence which lens you use. A wide-angle lens is useful if you want to record your subject's surroundings. Selecting a lens of a longer focal length concentrates attention on a particular feature, excluding distractions and so simplifying the image. Including a central point of interest in this way gives the eye an area on which to settle. It is usual to position the main subject in the middle of

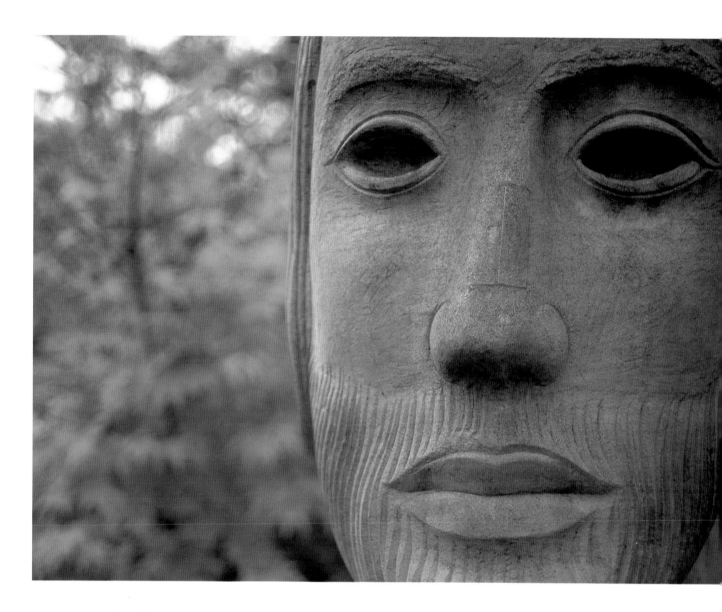

your picture, but having it off-centre may make for a more dynamic image. If you have two different subjects, positioning the larger one closer to the centre of the picture creates a more balanced composition.

The rectangular format provided by most cameras allows you to compose your picture either horizontally or vertically. Our binocular vision means that we see horizontally, and so the horizontal format seems normal and tends to be the one we use most. It can be interesting to look through recently developed films and check the proportion of vertical to horizontal shots that you have taken. Naturally vertical subjects include trees, many buildings and the human figure. Try to vary the format used to create less predictable images, and also try

John Skelton's sculpture of Janus in the Southover Grange Gardens, Lewes, England, is positioned to one side of the frame to heighten the drama of the face and allow the rich autumn colour of the tree behind to be seen.
Underexposing the face makes it seem more mysterious.
28–80mm zoom lens, Fuji Provia (100 ISO), 1/45sec at f/5.6

Compare the use of a horizontal format for this celandine-lined path with the vertical format. While the vertical frame has forced the omission of the monument on the left, it has made the path seem longer and increased the sense of movement in the image.
28–80mm zoom lens, Fuji Astia, tripod, 1/20sec at f/13

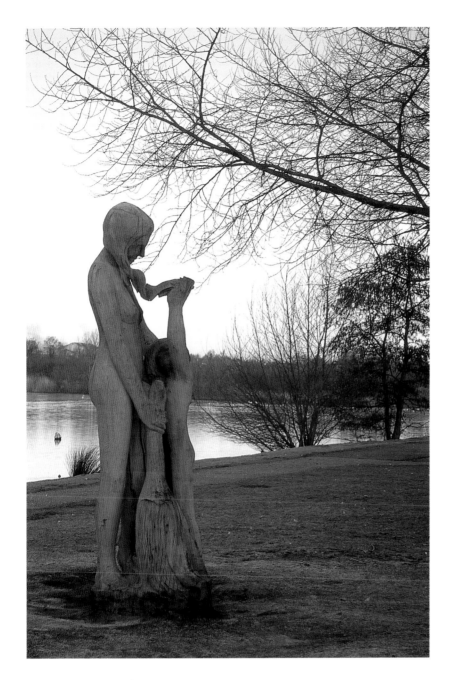

A vertical format was the natural choice for this image of the sculpture at Needham Market lake in Suffolk, England. *28–80mm zoom lens, Fuji Astia, tripod, 1/10sec at f/22*

taking both horizontally and vertically composed pictures of a suitable subject and compare the results. The panoramic format is an exaggeration of the normal rectangle, and is useful for sweeping landscape views or for images of tall trees.

The edges of a photograph are the natural frame to your image, and the way you have composed that image will have a great effect on the way that it is viewed. A repeated pattern carried right to the edge of the frame suggests that the pattern will continue beyond the edge, making a more

Foliage forms a natural frame for this view of Blakenham Woodland Garden, England. The restricted colour palette and soft focus add to the restful feel of the image.
28–80mm zoom lens, Fuji Astia, 1/45sec at f/8

dynamic image than one that has a neutral border. A frame within the frame – for example using the boughs of a tree or a garden arch to frame a view – gives a more static image, focusing the attention of the viewer within the picture.

LOOKING FOR SHAPE, PATTERN AND COLOUR

Lines within a picture can be used to encourage the eye to move around the frame in a particular way. It is often suggested that short people should avoid wearing clothes with horizontal stripes; vertical stripes are better as they encourage the eye to travel up and down. Similarly, horizontal lines in a photograph tend to have less implied movement than vertical lines. A curved line – perhaps in a sweeping border or the close-up of a petal – adds movement, carrying the eye around the picture. Diagonal lines often produce a highly dynamic image. Converging lines will be emphasized when using a wide-angle lens, giving a suggestion of greater depth to your picture.

This curved border edge forms a strong line, leading your eye around the garden.
28–80mm zoom lens, Fuji Velvia, tripod, 1/10sec at f/22

This sculpture is located at Godinton House in Kent, England. The strong lines lead your eye to the left of the picture, but gaps between the columns reveal planting in the border behind.
28–80mm zoom lens, Fuji Astia, 1/90sec at f/11

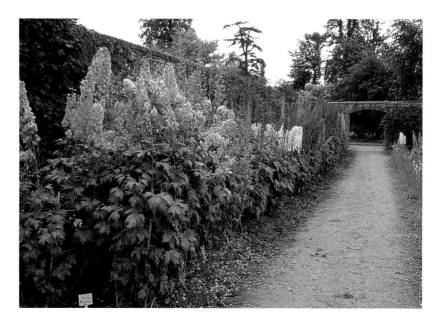

These two pictures of a delphinium border show how moving position just one pace can have a big effect on the final photograph. In the first image your eye tends to follow the path straight down and out of the garden. In the second image, for which I moved slightly to the right, the dynamics of the image are altered and your focus rests for longer on the delphiniums. *28–80mm zoom lens, Fuji Astia, 1/45sec at f/11*

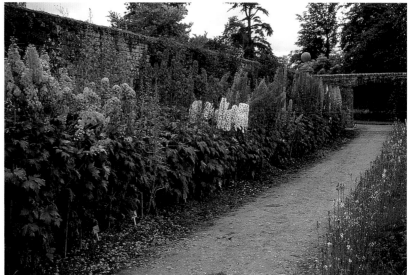

Look for shapes in the garden that can be used to create a strongly graphic picture. Squares and rectangles echo normal photographic frames and tend to form static images. The converging diagonals of a triangle are more dynamic, and direct the way an image is looked at. There is a tendency for the eye to draw its own triangle from any three similar points in a scene, and the implied triangle created in this way gives a feeling of connection and order to a picture. Circles tend to draw the eye inward, encouraging the viewer to focus on a central point of interest, and the exploding firework effect of plants like yuccas and cordylines can be exploited to make dramatic pictures. Repeated patterns add strength to an

image, so look out for pattern in a garden, whether it be repeated clumps of an individual plant in a border, overlapping leaves or herringbone brickwork in a path.

The effect of colour is equally important in controlling the eye. Strong colours will always attract the eye, focusing attention on that part of the photograph. This is especially the case when contrasting colours are used, such as red and green or blue and orange. The traditional riot of colour of a flower-filled border may be a very tempting subject, but remember that the simplest image is often the most effective – you may create more impact by just focusing on two or three of the flowers.

Try simple studio set-ups to experiment with colour. Here I've added colour matches for the scarlet *Cyrtanthus speciosus*. Although red is normally considered a dominant colour, in this case the small quantity of green in the pepper stalks tends to draw the eye.
Sigma 50mm macro lens, Fuji Velvia, tripod, 1/20sec at f/45

This vivid combination of hot pinks and reds was admired in the glasshouse at the Botanic Garden in Birmingham, England.
28–80mm zoom lens, Fuji Provia (100 ISO), 1/30sec at f/5.6

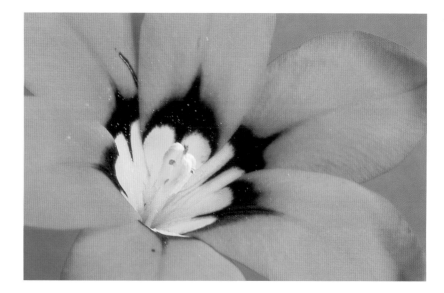

A contrasting deep blue background balances the vivid orange petals of this sparaxis flower.
Sigma 50mm macro lens, Fuji Astia, 1/30sec at f/45

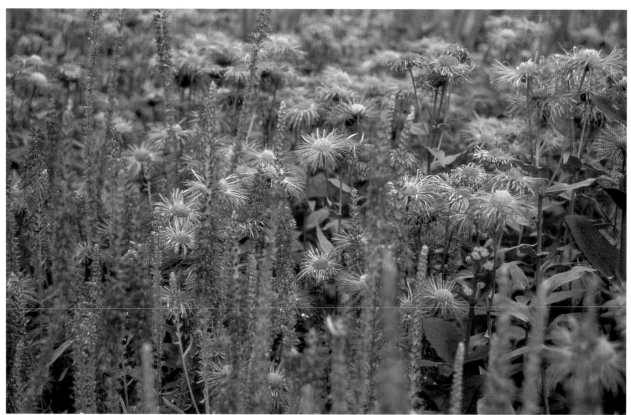

Subtler shades of colour combine in this planting of veronica and erigeron, and the soft lighting helps to convey a muted effect.
28–80mm zoom lens, Fuji Astia, 1/60sec at f/11

Colour harmonies, where softer tones are combined together, produce more restful images, encouraging the eye to linger. Always be on the look out for good plant partnerships and pleasing combinations of shape, texture and colour. Remember that light colours attract the eye, whereas dark colours tend to recede. You can use this to emphasize depth in a photograph by carefully selecting the viewpoint.

DEPTH OF FIELD
AND FOCUSING

Having chosen and framed your picture to your satisfaction, the next consideration is focusing. Many cameras will decide automatically which is your main subject and focus the lens accordingly. However, being able to retain control over focus and depth of field allows for much more artistic input in your work.

Depth of field is the distance between the closest and furthest points that are in sharp focus in an image. It is controlled by altering the size of the lens aperture – a smaller lens aperture (indicated by a large f-number) gives a greater depth of field. The focal length of a lens also affects depth of field, meaning that lenses with shorter focal lengths give a greater depth of field than telephoto lenses at the same shooting distance. Focus the lens along the plane of your main subject and then use the lens aperture to alter the depth of field, bearing in mind that the depth of field behind the main point of focus is generally deeper than that in front of the main focus point.

Altering the main point of focus between these two images changes the emphasis of the picture from that of the gardener to that of his flowers.
28–80mm zoom lens, Fuji Astia, tripod, 1/90sec at f/5.6

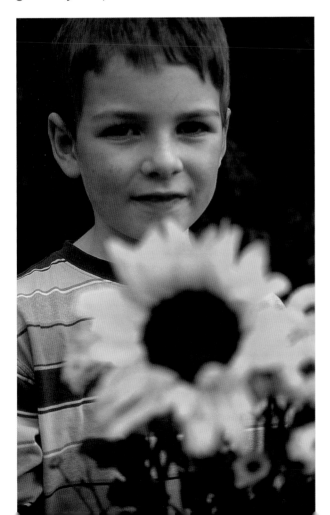

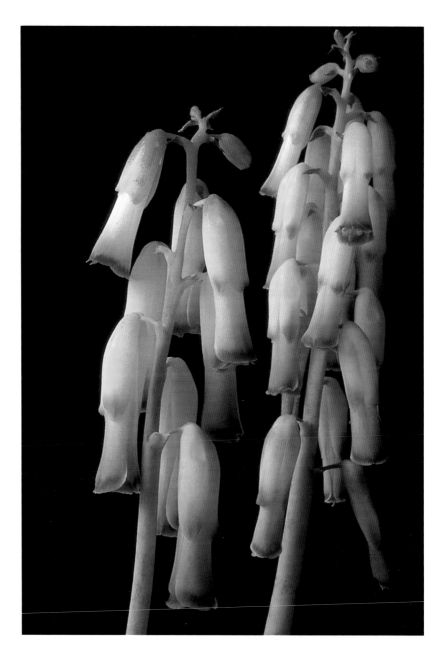

To show as much detail as possible in this portrait of the South African bulb *Lachenalia aloides* var. *quadricolor*, I set the maximum aperture on my macro lens.
Sigma 50mm lens, Fuji Astia, tripod, 1/30sec at f/45

For a traditional plant portrait or garden view you may want to maximize depth of field. However, to isolate a subject from its surroundings, using a large aperture will throw the background out of focus. Many modern flower images use a very shallow depth of field to artistically blur the image. If you like this style of photography, decide whether there is a particular part of the subject at which you want to direct attention. With a human portrait this would be the eyes, with a daisy it would probably be the central fertile florets. Focus your lens at this point of interest and then set a large aperture to ensure that the rest of the flower is in soft focus.

If your camera has a depth-of-field preview button you can stop down the lens to see if you have achieved the desired effect. When photographing garden views there is plenty of scope for altering the depth of field. When the camera is closer to the subject, however, the depth of field will be reduced. At high magnifications the depth of field is greatly limited, so it is important to align the camera back parallel with the subject and to pay close attention to accurate focusing.

For this image of *Paeonia tenuifolia* 'Plena' I wanted a very shallow depth of field to give a soft, romantic image. This technique also hides the fact that it was really a rather scruffy flower and would not have been suitable for a traditional portrait. *Sigma 50mm lens, Fuji Astia, tripod, 1/500sec at f/2.8*

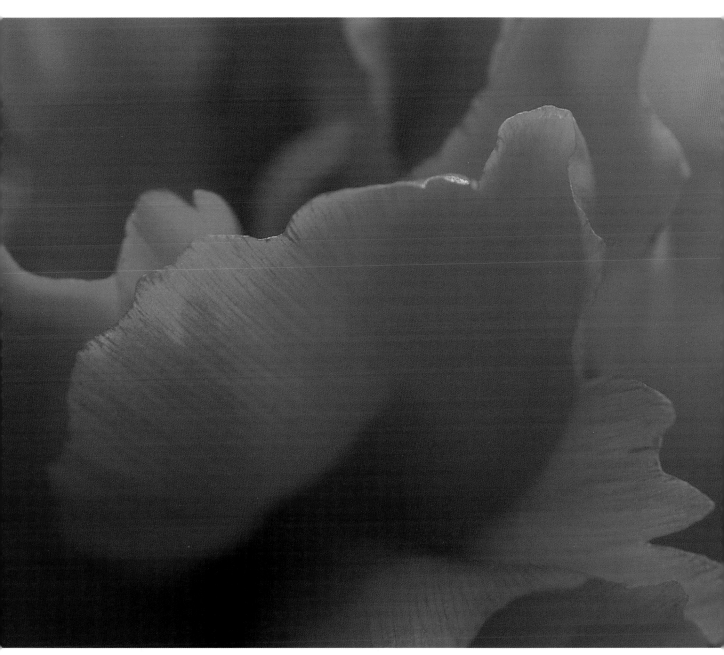

EXPOSURE

LENS APERTURE AND SHUTTER SPEED.

MEASURING LIGHT.

PROBLEMS IN HIGH-CONTRAST SITUATIONS.

BRACKETING.

LOW LIGHT AND RECIPROCITY FAILURE.

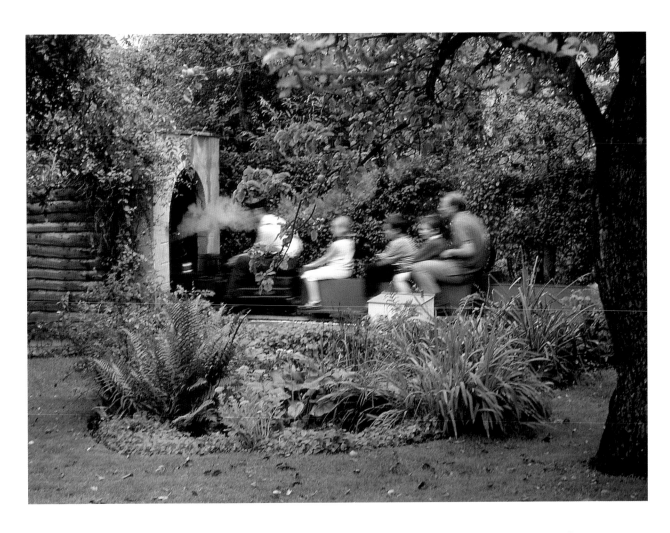

A slow shutter speed has been used to blur the image of this miniature steam train, emphasizing the sense of motion.

28–80mm zoom lens, Kodachrome 64, 1/10sec at f/11

Exposure occurs when light falls on the film. Correct exposure depends on the film being exposed to the proper amount of light, as determined by that particular film's sensitivity to light. An underexposed film results in dark images, whereas a film that is overexposed gives pale, washed-out pictures. Exposure is controlled by a combination of lens aperture and shutter speed.

LENS APERTURE AND SHUTTER SPEED

The lens aperture is the size of the opening in the lens, and adjusting the aperture will alter the amount of light that passes through to strike the film. The aperture is altered in a series of steps referred to as f-stops or f-numbers. A typical numbering of f-stops ranges from 1 to 45 (in a sequence beginning 1, 1.4, 2, 2.8, 4, 5.6, 8, 11) where the numbers increase by the square root of two. The range of possible apertures varies with individual lenses. Confusingly, an increase in f-number decreases the size of the aperture opening, reducing the light received by the film. Altering the aperture from f/8 to f/11 halves the aperture, thus halving the exposure. If you are photographing a dark scene, a larger aperture (smaller f-stop) must be set than if you were working in bright sunlight. Using a large aperture is usually also necessary when using a slower film or for hand-held cameras. This will reduce the depth of field that you are able to obtain, and so the lens must be focused more accurately.

The shutter speed controls the length of time that the film is exposed. It is measured in seconds and fractions of a second. Various cameras will have different ranges of shutter speeds. My Canon EOS 300 SLR camera has a range from 30 seconds to 1/2000 of a second, and a bulb facility that makes it possible to keep the shutter open for as long as the shutter release is depressed. (This feature can be used with a remote switch to save you having to hold down the shutter button for long exposures.)

As with lens aperture, shutter speeds increase in a series of steps, each incremental setting being called a stop. A fast shutter speed can be used to freeze movement, either of the

Two different effects have been obtained by altering the shutter speed of these images showing part of the waterfall. The first image uses a shutter speed of 1/60 of a second (at f/4.5); for the second image the shutter speed is reduced to 1/4 of a second (at f/22), blurring the water.

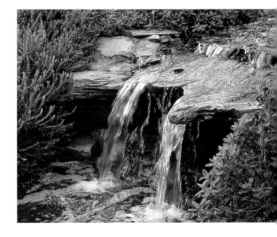

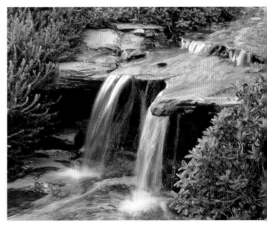

subject or the camera shake that occurs when the camera is hand held. To freeze the movement of a wind-tossed flower or to arrest a water droplet in mid-flow you may need a shutter speed of 1/250 of a second or faster. Sometimes you may want to use a slow shutter speed to blur the image artistically, perhaps to emphasize movement. (Blurring due to movement has a streaked appearance different to that caused by poor focusing.) Photographers often use a slow shutter speed of half a second or longer when photographing moving water, as this will reduce the water to a milky blur. This is an acceptable use of the slower shutter speeds, but because this is not how our eyes actually see water it can look rather contrived. For a more natural look, choose a shutter speed between about 1/60 to 1/125 of a second.

Lens aperture and shutter speed work together in a reciprocal one-stop relationship. This balanced relationship makes it possible to get the same degree of exposure from a series of different settings. For example, a scene that is correctly exposed with a lens aperture of f/5.6 and a shutter speed of 1/30 of a second will receive the same exposure from settings of f/11 and 1/8 of a second. In some cases, practical considerations determine which combination to use: if you were holding your camera by hand you would use the faster shutter speed to reduce camera shake; if you had a tripod you could make use of the smaller aperture (f/11 rather than f/5.6) to give greater depth of field. In other cases it is purely a matter of personal preference which combination of settings you choose. You may want to under- or overexpose a shot deliberately to create a particular effect. Sunset pictures often have a richer, more brooding feel if they are underexposed. Misty or

Flat arable fields surround our garden, but this line of trees makes an appealing subject for sunset scenes. Exposing the image for one stop less than the value suggested by the camera's meter has enriched the colours of the sky.
80–200mm zoom lens, Fuji Astia, tripod, 1/8sec at f/9.5

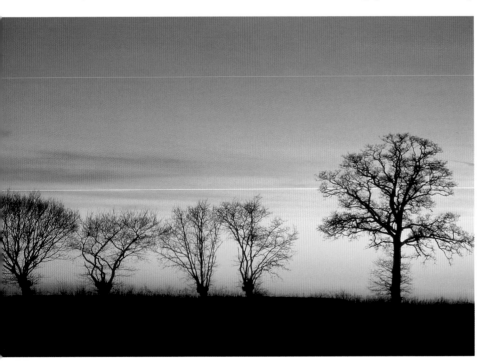

foggy scenes can be overexposed to whiten them for a ghostly mood. Also, transparency films often give more saturated colours if they are underexposed by half a stop. Many cameras have an exposure compensation setting so that you can change the exposure level set by the camera to make your pictures darker or brighter.

MEASURING LIGHT

Most modern cameras have a built-in light meter that will work out the 'correct' exposure for you in a range of different situations. Through-the-lens (TTL) metering systems are becoming increasingly sophisticated. They work by taking light readings from different parts of the subject and then using the camera's computer to assess the ideal exposure based on model lighting situations that have been programmed into its memory. Usually they give good results in evenly lit situations, but because the readings taken by TTL meters are based on reflected light, they will be influenced by the colour tone of your subject. Meters are calibrated for average tones, and even if you are photographing a very light or very dark subject they will try to record the average tone, which may give a false exposure value. With a very light subject, perhaps a snowy scene, the camera will cut down exposure because there is a large amount of reflected light. Unless you compensate for this the picture will be underexposed, with the snow appearing greyish. A very dark subject, such as a black dog, may 'trick' the meter into increasing exposure, giving an overexposed image.

Using a hand-held meter that records incident rather than reflected light will help you to overcome these problems. However, the experience that comes with using your camera for a diverse range of

To allow for the increased light reflected by the snow, I overexposed this image of the frozen pond by one stop.
28–80mm zoom lens, Fuji Provia (100 ISO), tripod, 1/30sec at f/22

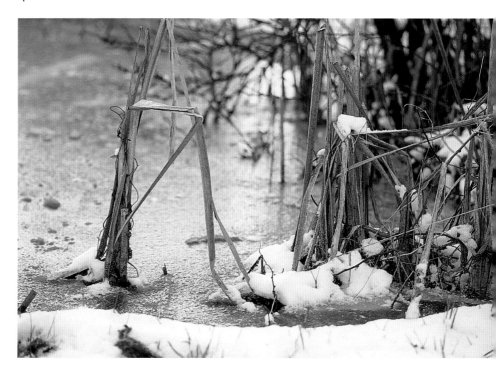

subjects and in a number of different lighting situations will enable you to anticipate, and compensate for, times when the camera meter cannot cope.

PROBLEMS IN HIGH-CONTRAST SITUATIONS

In difficult metering situations, first take an exposure reading from a neutral-toned subject – an area of green lawn or a neutral-coloured rock would be ideal – or use a sheet of photographic grey card placed in front of your subject. Use the exposure lock or manually set this reading, and reframe on your chosen subject. Consider this reading a baseline value and if your main subject is very light or dark adjust the value accordingly. In high-contrast conditions, you may have to decide whether to meter for the light or dark areas. Sometimes it is helpful to recompose your picture so that a loss of detail either in the shadows or the highly lit areas is of little importance.

When small subjects have a strongly contrasting background you can compose and focus your pictures and then, without altering the focus, move your camera in closer so that the subject fills the viewfinder. Take a reading at this point and then return to your original poistion. (You should not refocus the lens on moving closer as this would alter the exposure value.) Some cameras provide a warning system if there is likely to be a problem with exposure, for example if the subject is too bright for even the fastest shutter speed and so you need to use a neutral-density filter to reduce the amount of light.

BRACKETING

It is a good idea to bracket your exposures, especially when taking important shots. This means taking one shot using the exposure suggested by your camera (or that you have decided on) and then one or two additional shots at exposures above and below that reading, so ensuring that you have at least one picture that is exposed 'correctly'. This is particularly beneficial

with transparency films, as they have less exposure latitude than negative films. With negative films, you can bracket one whole stop on either side of the estimated exposure value; for transparencies a half stop may be more appropriate. An automatic exposure-bracketing facility on your camera enables the camera to automatically change the exposure level within a set range for three successive frames. When using a camera without this facility you can use the exposure compensation dial or reset the film speed. For example, if you are using a ISO 100 film and set the film speed to ISO 160 or ISO 200 the film would be underexposed. Conversely, to overexpose set it to ISO 64 or ISO 50. As an alternative you could manually change the lens aperture or shutter speed.

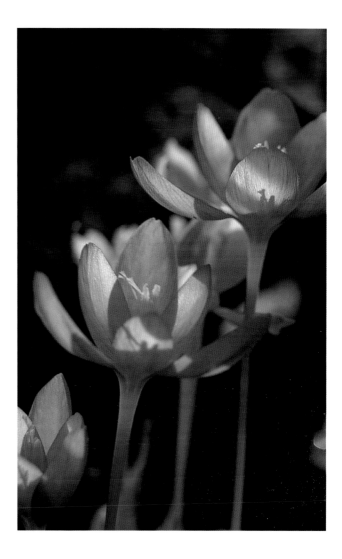

LOW LIGHT AND RECIPROCITY FAILURE

As described previously, there is a reciprocal relationship between aperture and shutter speed, allowing the photographer to choose between equivalent exposure settings of, perhaps, 1/45 of a second at f/4 or half a second at f/16. However, at long exposure times of over one second the rate at which the film absorbs light slows and the reciprocal relationship breaks down. This is called 'reciprocity failure', and unless more exposure time is allowed than that indicated by the camera meter, pictures will be underexposed. It can be a particular problem when taking photographs of twilit scenes or in shady woodland conditions. Increasing the exposure time exaggerates the problem and abnormally long exposure times can cause colour shifts in the film, so if possible use a larger aperture rather than a slower shutter speed to compensate.

Strong shafts of sunlight can confuse your camera's light meter. To ensure a correctly exposed shot of these *Crocus goulimyi*, I bracketed exposures by a half and one stop.
28–80mm zoom lens, 13mm extension tube, Fuji Velvia, tripod, 0.7sec at f/32

LIGHTING

LIGHT INTENSITY.

ARTIFICIAL LIGHT AND SIMPLE STUDIO WORK.

THE DIRECTION OF LIGHT.

THE COLOUR OF LIGHT.

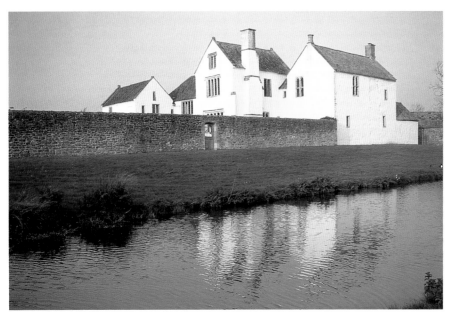

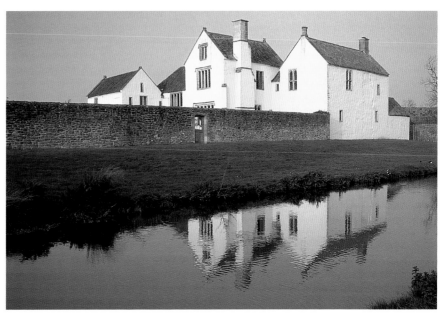

Low, bright afternoon light gives a strong reflection of Gurney Manor in Somerset, England, but notice the difference made to the reflection in the second image by waiting for the wind to drop.
80–200mm zoom lens, Fuji Astia, tripod, 2secs at f/32

More than anything else it is lighting that can make or break a photograph. Even something as mundane as a stinging nettle can be transformed into a thing of beauty by a correctly placed shaft of light. It is easy to be seduced by a wonderful picture in a gardening magazine, but I doubt that I am the only gardener who, having acquired the object of desire, has found that it turns out to be a rather dull and disappointing plant. Conversely, the most incredibly flamboyant flower can make a drab photograph if the lighting is flat.

Natural lighting can change dramatically within a very short space of time, which can make garden photography a challenging and often frustrating undertaking. However, when the light is right and you get an exciting image it can be extremely satisfying.

The strong back lighting of this flower of *Clematis* 'Madame Grange' gives an iridescent look to the sepals.
Sigma 50mm macro lens, Fuji Astia, tripod, 1/1500sec at f/8

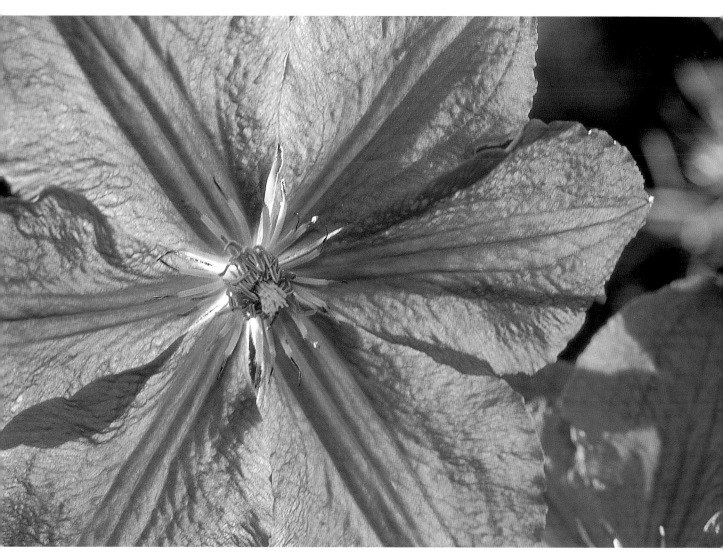

LIGHT INTENSITY

Light varies tremendously in both quantity and quality. Obviously the sun intensity in South Africa is much greater than in Britain – as shown by many South African bulbs struggling to flower on northern-hemisphere windowsills. Even within your own garden, the amount of light alters greatly throughout the year, as well as over the course of a single day.

Bright sunlight is perhaps thought traditionally to be ideal for outdoor photography: colours look brighter and stronger, and the high intensity of light means that you can use small apertures to achieve good depth of field without having to resort to long exposure times, which is helpful if you are not using a tripod. However, it is difficult for camera film to cope with the high contrast between light and shade, and intense sunlight can make photographs look very harsh. In these conditions choose your viewpoint with care to maximize the drama of deep shadows, or perhaps to exclude them from the frame, concentrating solely on highly lit areas. The use of reflectors or fill-in flash should also be considered. These reduce contrast levels by increasing the light levels in shaded areas. A built-in camera flash is useful for providing fill-in light at short distances, although the power levels of such flashes are too low for longer ranges.

Even light clouds will weaken the intensity of the sun and, on a windy day, light levels can fluctuate wildly as clouds are blown across the sky. A bright but overcast day makes exposure decisions much easier and can produce some very good results. Colours often appear richer under these conditions because glare is minimized. Diffused lighting is ideal for close-ups in particular, as the lack of contrast allows details to be seen clearly. The dappled light created by sunlight passing through foliage is particularly difficult to expose for. It is generally more effective to expose for the highlights, creating pools of deep shade. Shafts of light produced as the sun appears through clouds or gaps in planting can be exploited to dramatic effect, but you need to work quickly as such lighting is usually transient.

When recording long garden views, watch out for haze (caused by dust, pollution or water particles in the atmosphere, which

Taking pictures in the rain can help to enrich colours, as in this image of a hybrid lily. Make sure that you wipe any raindrops off your equipment afterwards.
Sigma 50mm macro lens,
Fuji Astia, tripod, 0.7sec at f/19

scatter the light). Sometimes it may result in pleasing effects, giving a bluer light and soft pastel tones to landscapes. However, to cut haze and reveal more of the detail and colour in a scene, use an ultraviolet filter or, when using black-and-white film, an orange or red filter. A polarizing filter will also reduce haze, particularly when you are working at right angles to the sun. (See pages 44–48 for more information on filters.)

The sun's light is less intense during the early morning and the evening, when the sun is low on the horizon and its rays must travel through more of the earth's atmosphere. These times tend to be those most favoured by landscape and garden photographers, as contrast between light and shade is reduced and the existence of long shadows helps to emphasize depth and texture in a scene. Pointing your camera at the sun in the middle of the day will damage both your camera shutter and your eyes, but when the sun is low and weakened by light clouds or haze, shooting into the sun can give particularly atmospheric images. Sometimes the colours fade from the surroundings at twilight (that light remaining once the sun has set), but occasionally colours intensify for a few moments, with clouds reflecting dramatic reds and oranges against the inky blue of the sky. In these conditions, the incident-light reading from a hand-held meter would be the most accurate guide to exposure settings.

Warm evening light enriches the red colours of this brickwork.
28–80mm zoom lens,
Fuji Astia, tripod, 2secs at f/22

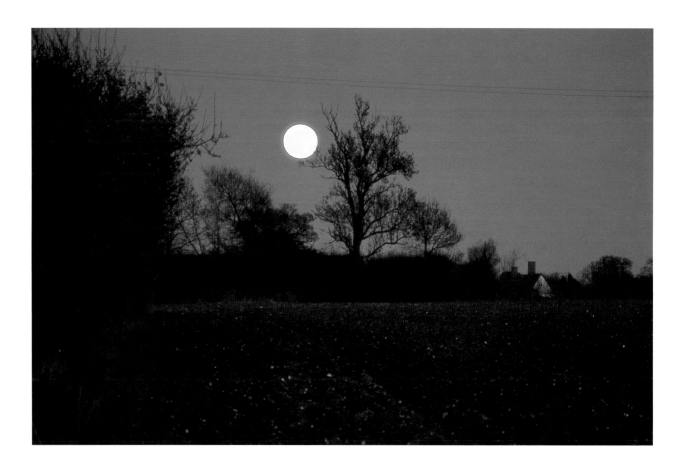

A tripod is essential for the long exposures needed to take pictures at night. Beware of reciprocity failure in your film once the exposures last a matter of seconds.
80–200mm zoom lens,
Fuji Astia, tripod, 20secs at f/5.6

To take photographs of your garden lit by moonlight, when the light intensity can be some 20 stops less than in daytime, very long exposures of several minutes may be required. This means that a tripod or other form of camera support is essential. Exposure readings in these conditions may be beyond the range of an ordinary light meter and there is the possibility of reciprocity failure in the film, so finding the required settings may be a case of trial and error. If you want to include the moon in your photograph you need a long telephoto lens to ensure that it will be a reasonable size in the frame. The moon moves through the sky surprisingly quickly when viewed through a lens, so set the maximum aperture to allow the shortest shutter speed and prevent this movement from causing blurring.

THE DIRECTION OF LIGHT

The direction of light can have a dramatic effect on your images. Traditional advice was to take your photograph with the sun behind you. This gives an evenly lit scene that is

strong in detail and easy to meter for. However, this frontal lighting can give a rather flat result as the shadows that emphasize depth and texture are minimized.

Side lighting is particularly good for emphasizing the three-dimensional form and surface texture of your subject; the effect of shadow accentuates contours and details of relief. Contrast levels will be high and you may need to expose for the light side of the subject at the expense of details in the shaded side, although reflectors or flash can be used to fill in details in the shadows of small subjects. Side lighting is most effective with simple subjects, as a mass of different shadows can cause confusion.

Back lighting, where the light source is behind the subject, can create some of the most beautiful images. When the edges of a subject catch the light, a bright outline is produced. This halo-like effect is known as 'rim lighting', and looks especially dramatic against a dark background. Back lighting is

Strong side lighting is beneficial in emphasizing the texture and form of your subject, as with the amazing brain-like convolutions of this Mammilaria elongata f. cristata.
Sigma 50mm macro lens, Fuji Provia (100 ISO), tripod, 1/2sec at f/45

particularly effective with translucent subjects such as flowers and foliage, and is an excellent way to highlight surface details such as hairs or glands on a plant. Additionally, shadows falling towards the camera emphasize three-dimensional form.

With strong back lighting, much of the detail of your subject will be shaded. You can use reflectors or fill-in flash to reveal details, or you can take advantage of the silhouette effect. Try using different exposures to obtain some pictures with subject detail and others as silhouettes. With back lighting there is an increased risk of flare and spots of light caused by internal reflections on the lens. (Stopping down the lens with a depth of field preview button enables you to see how much flare will occur.) Making sure that you shade the lens in some way, such as using a lens hood, can reduce the risk of these effects when they are not wanted. Alternatively, if possible, choose a viewpoint that is in the shadow of a building or tree. While flare can cause a reduction in definition, it may enhance a photograph by giving a lower image contrast and a romantic misty appearance, particularly at dawn and dusk.

THE COLOUR OF LIGHT

Even with natural lighting, colour temperature can vary greatly. As already indicated, at sunrise and sunset the light rays have to travel through more of the earth's atmosphere. This absorbs ultraviolet and blue radiation, and the light appears to be redder. Against a clear sky, light appears bluer, whereas at midday in summer light is white. These changes in colour echo changes in temperature from red-hot to white heat, which is why the term 'colour temperature' is used to describe differences in the colour of light.

The human eye can make quite sophisticated adjustments to compensate for changes in the colour of light, and for the most part they are not perceived. Usual daylight film, however, is balanced for the midday sun, so photographs taken at dawn or dusk may show a strong yellow or reddish cast. This warm, flattering light can be desirable, but if you want to record the true colour of a flower you can use a pale-blue colour-compensation filter to offset its effects.

The greatest range of colours in the sky is usually found just before sunrise, which is why many landscape photographers are early risers. If, however, you are someone who finds getting out of bed early impossible, you can take consolation from the fact that light quality at sunrise is often indistinguishable from that at sunset to someone viewing the resulting photographs.

At high altitudes, the thin atmosphere screens out fewer ultraviolet rays and the film may record a blue cast. If you are photographing in the mountains you may want to retain this cast for a sense of atmosphere, but it can be removed with an ultraviolet filter. Care should be taken when using a polarizer filter at high altitude, as it can make skies look unacceptably dark.

ARTIFICIAL LIGHTING AND SIMPLE STUDIO WORK

The vast majority of garden photography is done outdoors using natural light, with the occasional use of fill-in flash. However, there may be occasions when you want to take pictures indoors, perhaps to record a favourite houseplant or a striking display at a flower show. Generally, the human eye perceives tungsten lighting (i.e. the light created by a normal, tungsten-filament bulb) as more or less white. In actual fact, the real colour temperature of tungsten light is orange. Daylight-balanced film will reproduce the colour as it really is, and to convert it to the colour we would normally see, you must either use a colour film balanced for tungsten light or 'add' blue using a colour-conversion filter (80A or equivalent). The digital manipulation of images (using a computer) can of course also be used to correct colour casts.

Fluorescent lighting varies in colour temperature, although such lamps often produce a greenish cast. If this creates a problem, it may be worth trying a Kodak Wratten CC30 Magenta filter (or equivalent), or a FL-D filter, which is specifically designed to balance florescent light. Another potential problem with fluorescent lamps is that they flicker. This is not usually discernible to the naked eye, but may become apparent if you use a shutter speed faster than 1/30 of a second.

The unusual lighting effect on this cherry tree is the result of using daylight-balanced film for branches lit by an outdoor tungsten lamp.
80–200mm zoom lens,
Fuji Provia (100 ISO), tripod,
8secs at f/5.6

All too often it seems that just as your garden is at its best a spell of wind and rain threatens to strip leaves from the trees and reduce flowers to a pulp. Having a simple studio, which can be as basic as the kitchen worktop, gives you the flexibility to cut flowers and practise your photography skills in any weather and at any time of the day or night. I use a basic glass lean-to on the side of our home, which provides plenty of light. One drawback is that it is quite draughty, so fragile flowers sometimes have to be protected by a windbreak if I am using long exposures.

Reflectors can be used to boost ambient light levels. A manufactured reflector may be the quickest to use, but impromptu reflectors can be made from kitchen foil, sheets of white card or a white sheet.

Flash may be needed in cases where natural light is insufficient to allow good depth of field, and the built-in flash of most cameras can be used for supplementary lighting. Keep at least 3ft (1m) away from the subject and make sure you remove any lens hoods, which may obstruct the flash coverage. It is also important to be aware that cameras have a maximum shutter speed at which it is possible to synchronize the flash with the shutter, often 1/90 or 1/250 of a second.

In this still life of squashes, the use of a simple white card reflector supplemented the very soft natural lighting.
Sigma 50mm macro lens,
Fuji Astia, tripod, 2secs at f/45

With a separate flash unit you can place the flash to the side of the subject, which usually creates a better, more three-dimensional image. Studio lights are high-powered flash guns that need to be supported on stands. They are powered by mains electricity so that they can recharge quickly, and it is possible to set them to different brightness levels. A single light when used with reflectors would be adequate for most needs. Studio lights should recreate daylight and so are usually set higher than the subject. Soft box attachments may be fitted over the head to give a diffused, more natural light. For close-ups, and especially if you do a lot of extreme close-up work, you can get a special ring flash which fits around the lens and provides high-intensity light for bright, shadowless images.

As with outdoor photography, you need to pay attention to the choice of background, as this will have a big effect on your image. Large sheets of cardboard are available from art shops in a wide range of colours, or you can put together a studio backdrop with planks of wood or draped fabric. The black background in many of my flower portraits was achieved using a black velvet skirt, which is large enough to act as a drop to all but the biggest of flowers. Raiding your wardrobe may produce several suitable items; look for fabrics with an appealing texture, such as silks and linen. Some people find such backgrounds anathema and prefer to use only 'natural' backdrops. They may find using other plants or a background of overlapping leaves more pleasing.

I often use my light box to supplement natural lighting as it has a daylight-balanced tube, and the opalescent screen diffuses the light well. It can also be used as an unusual background for plant portraits – the ultimate in back lighting perhaps. Stand the light box on its side with your subject in front and place reflectors either side of the camera to bounce light to the front of your subject. The higher light level of the background will ensure that it is overexposed and appears a pure white. Translucent subjects

arranged directly on the light box reveal fascinating patterns of veins and cells. This technique is often used for autumn leaves, but also works well with thin slices of fruits and vegetables, as well as flowers and seeds. To maximize the effect and make back lighting the only light source, you can work in a darkened room. This method of photographing plants enables you to carry on working even when the weather outside is unsuitable.

For this picture, the gerbera flower heads were placed in a glass bowl of water, which was positioned on my light box. *Sigma 50mm macro lens, Fuji Velvia, tripod, 10secs at f/22*

SUBJECT
SELECTION

Photographing

your garden

THE BROAD PICTURE

THE GARDEN IN ITS SETTING.

VIEWS AND VISTAS.

Including the house in your picture gives a strong sense of identity. This image,
taken at The Harralds in Norfolk, England, has a very 'English country garden' feel to it.
28–80mm zoom lens, Fuji Velvia, 1/45sec at f/5.6

THE GARDEN IN ITS SETTING

One of the abiding principles of garden design is that the garden should be in harmony with its surroundings. Whether it is a country garden set in attractive scenery or a small urban garden 'borrowing' part of a neighbour's cherry tree, rarely can a garden be viewed in isolation. Pictures of the garden as part of a surrounding landscape are very useful in setting the scene, and when photographing a garden it is worthwhile keeping this principle in mind.

Even just a glimpse of the house through planting gives an image a greater sense of place.
28–80mm zoom lens, Fuji Velvia, tripod, 1/30sec at f/13

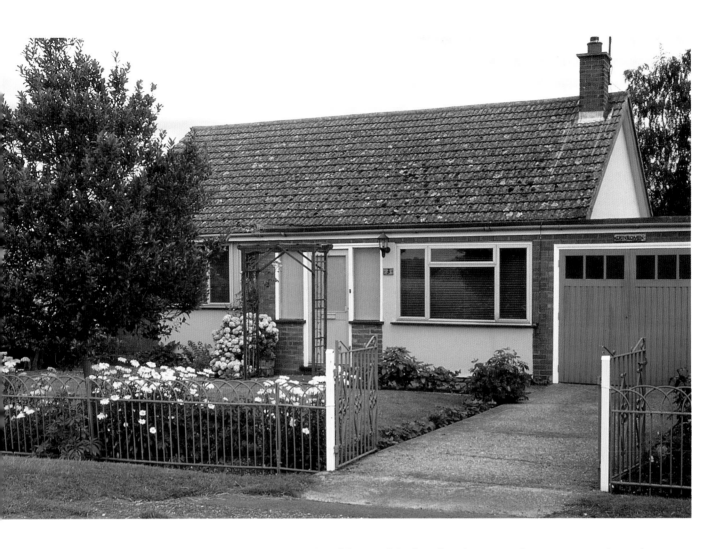

If taking a series of
photographs of your garden,
you could try to make a story
of it by introducing the garden
as if you were walking up to
the front gate, before entering
to tour the garden...
28–80mm zoom lens,
Fuji Velvia, tripod, f/16

Fields of flat arable farmland surround my own garden. The cow
parsley that blooms at the fields' edges is echoed in the
billowing lacy masses growing under our Bramley apple tree.
The tractor with plough and harrow or the combine harvester
working the fields is as much a part of our garden scene as the
pavement and street tree is to a small town garden. In many
urban settings the back gardens are intensely private, screened
by walls or fences, but the front gardens are open and pleasing
pictures can be obtained by showing how planting schemes in
one garden are repeated in many others. This is often a sign of
plant sharing among good neighbours, or may simply indicate
which plants will grow well in that particular environment.

When photographing front gardens, consideration must be
given to distractions such as rubbish bins or parked cars. While
the proud owner of a new car may appreciate seeing it included
in a photograph, it is unlikely to add to the composition of your

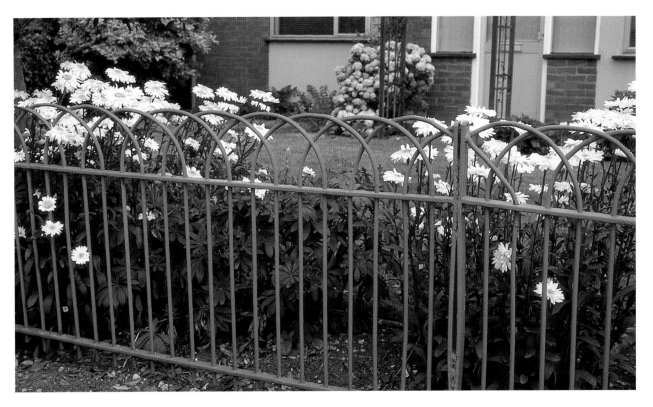

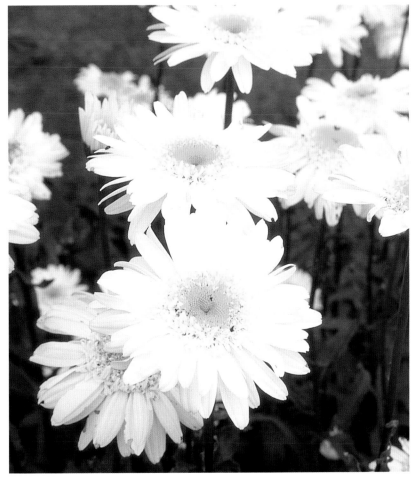

...these shots show progressively closer views of Shasta daisies peeping through a fence.
28–80mm zoom lens, Fuji Velvia, tripod, f/16

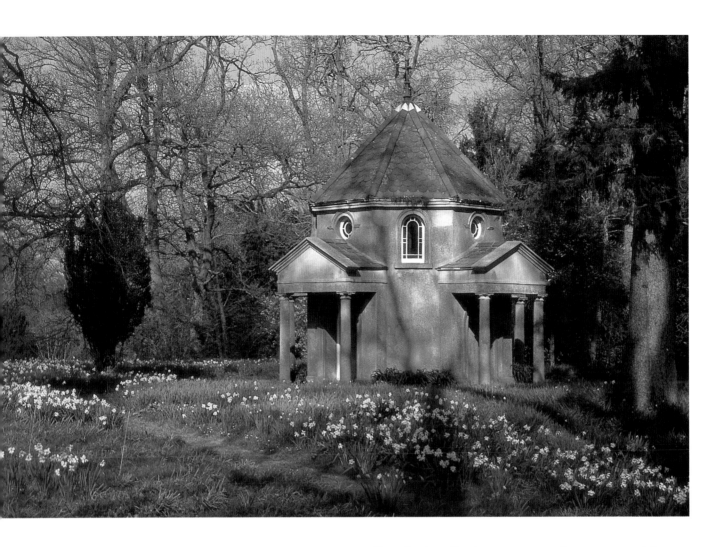

Dappled light creates a feeling of seclusion in this springtime picture of the summerhouse at Saxham Hall, Suffolk, England. *28–80mm zoom lens, Fuji Astia, 1/60sec at f/11*

picture and will undoubtedly date it. Try to choose a suitable time of day when photographing urban front gardens in order to minimize disturbance from passers-by and traffic. This is less of a problem for garden photographers who prefer to work during the early morning, when the light is soft and flattering. However, when a house is included in a shot, be aware that drawn curtains can give rather a blank look. As a result, late afternoon may be a better time to choose in this instance. Interesting pictures can be taken at dusk when white and blue flowers seem to become more prominent and street and house lighting can produce unusual effects.

Opposite: Black-and-white film draws attention to the texture and shape of these tool handles. *Sigma 50mm macro lens, Ilford 100 Delta, tripod, 4secs at f/27*

Including the house in the background of your garden photographs is probably the surest way of showing how the garden interacts with its locality. When photographing buildings and other architectural features there is a tendency to tilt the camera upward in order include the whole structure.

Colour film is used here for a winter view of the outside of my potting shed.
Sigma 50mm macro lens, Kodachrome 64, tripod, 0.7sec at f/22

This will cause the verticals in your picture to converge – a distortion that is amplified when using a wide-angle lens. To prevent this problem, always mount the camera on a tripod and ensure that the camera back is kept level. (To help ensure this, small spirit levels are available that can be attached to the hot-shoe fitting of the camera.)

If you take pictures of architectural features regularly, you may find it worthwhile investing in a shift lens, which is a special wide-angle lens designed to control perspective. The lens elements in shift lenses can be moved off their normal axis, tilting the lens alone, so that the photograph is composed without having to tilt the camera.

Opposite: Hedges followed by an arch and paired trees form a very strong vista at The Harralds in Gissing, Norfolk, England.
28–80mm zoom lens, Fuji Astia, 1/60sec at f/11

When considering garden buildings, as well as the more obvious photographic subjects – summerhouses, gazebos and garden follies – the potting shed and greenhouse often have many points of interest. These utilitarian structures have a workaday appeal that often translates well into black-and-white images. For general garden views, however, the added dimension produced through the use of colour is usually considered to be essential.

VIEWS AND VISTAS

The term 'view' can be applied to any scene under observation,
although it tends to imply a pleasant prospect. The word 'vista'
is usually reserved for a view seen through a long, narrow
opening where the view is in some way contained and therefore

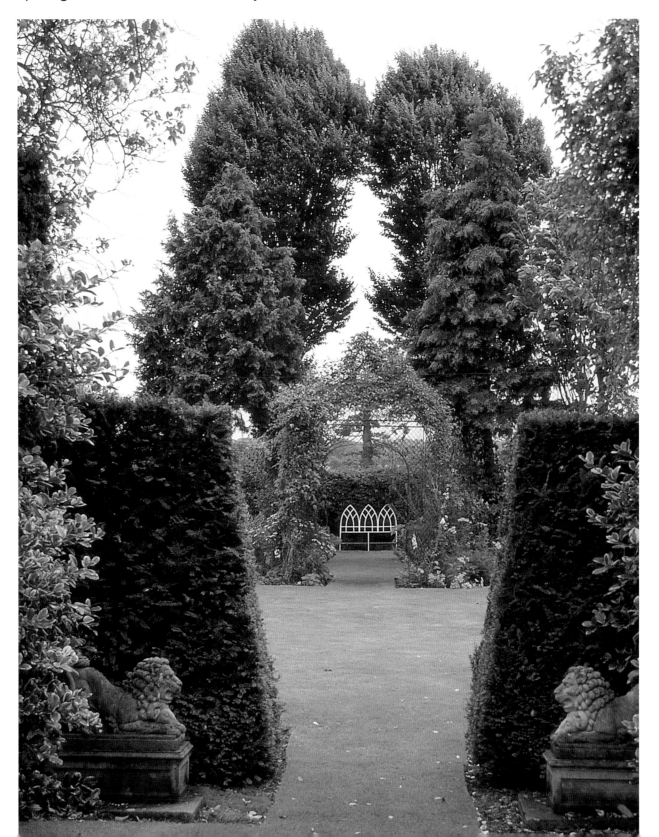

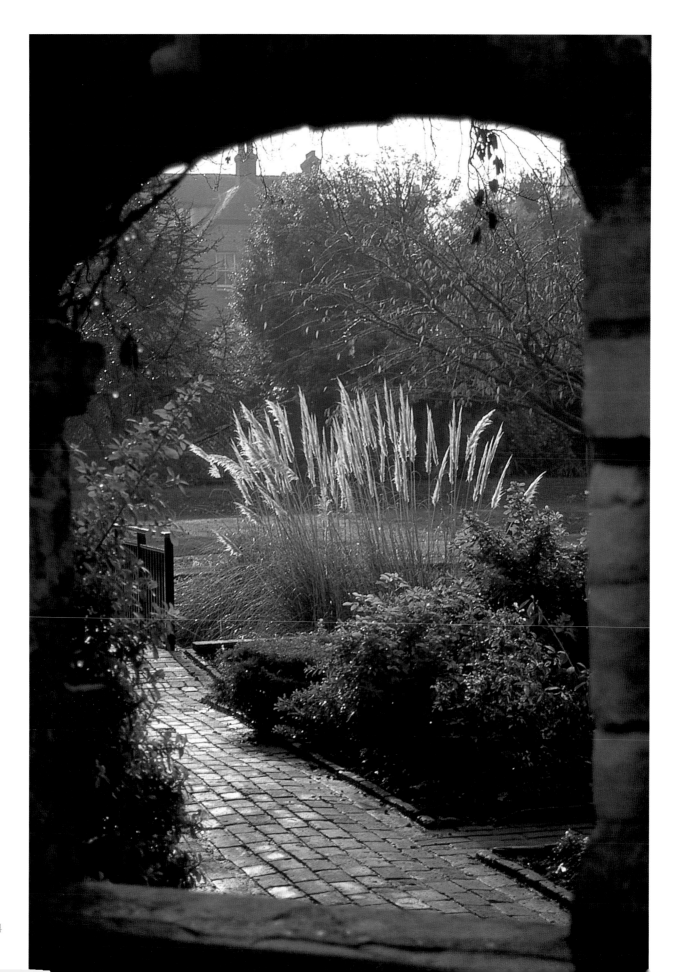

emphasized, such as an avenue of trees, twin hedges or double herbaceous borders. Strong vistas can have considerable impact, as demonstrated by the great popularity of the laburnum arch at Barnsley House in Gloucestershire, England, or the lime avenue at Château Villandry, France, which are very popular subjects. While in grand gardens the vista is usually very formal, the same linear concept can be seen in a simple path leading to a gate. Composing your picture vertically, rather than as a traditional horizontal landscape, will emphasize the length of a vista.

Photographs of garden views can be complemented by ones of the views that look out from a garden. Such pictures can be framed by positioning yourself behind an arch or pergola, and gaps in planting, the boughs of trees or breaks in hedges can be used to similar effect. Adding variety to the framing of your compositions in this way can help to prevent views looking too trite. To include a full scene use a wide-angle lens,

I could have used a UV filter for this shot to reduce haze and reveal more detail in the distance, but decided to keep the haze for the impression of greater depth it gives to the picture.
28–80mm zoom lens, Fuji Velvia, 1/60sec at f/16

Opposite: The stone archway is underexposed, forming a dark frame to the view of Southover Grange Gardens in Lewes, England.
28–80mm zoom lens, Fuji Provia (100 ISO), 1/60sec at f/9.5

Lesley Orrock's varied garden, Moverons, in Essex, England, has excellent views out over the Colne Estuary.
28–80mm zoom lens, Fuji Velvia, 1/60sec at f/11

which will give a greater sense of depth to the picture. Setting a small aperture will maximize the depth of field so that the whole scene is in sharp focus. It is helpful to focus the camera on something definite approximately one-third of the way into the scene. Gates, plant pots and architectural plants are all suitable focal points. If, however, you want the edges of your frame to be in soft focus, set a larger aperture and focus the camera on something at the centre of your picture.

Opposite top: I loved this romantic rose-covered gateway, revealing enticing glimpses through the garden at Godinton House in Kent, England.
28–80mm zoom lens, Fuji Astia, 1/90sec at f/11

Opposite bottom: This picture of the potager garden at Columbine Hall, Suffolk, England, was taken just before a torrential downpour.
28–80mm zoom lens, Fuji Astia, 1/60sec at f/9.5

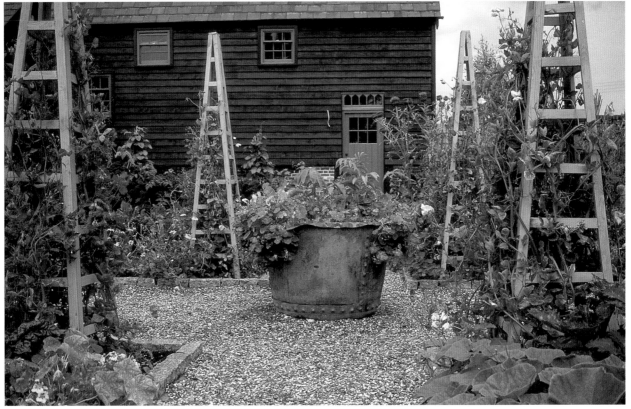

PEOPLE AND PETS

INCLUDING PEOPLE IN GARDEN PHOTOGRAPHS.

DOMESTIC ANIMALS AND PET PORTRAITS.

USE OF THE SELF-TIMER.

Some photographers like to include people in their images to give a sense
of scale, but different people view pictures in different ways.
28–80mm zoom lens, Fuji Velvia, polarizing filter, 1/60sec at f/13

There are vast numbers of illustrated garden books and magazines on the market. If you take the time to browse through a selection of them, it is surprising how few of the photographs show anything other than the plant life of the garden. Gardens are surely as much for people as for plants, but rarely are you allowed to catch a glimpse of the gardener at work or anyone enjoying the garden.

INCLUDING PEOPLE IN GARDEN PHOTOGRAPHS

Personally, I think that including people or animals in a photograph often helps to bring the image of a garden to life. Of course, it is not always possible to find someone who will agree to be included in your shot, in which case even the implication of someone's presence can be used to give your garden picture a lived-in feel. This can be achieved by including images of garden tools – a garden fork left in the vegetable patch, a wheelbarrow full of hedge trimmings or a pair of pruning clippers left on a potting bench all suggest that the gardener is around. Equally, a hat left on the lawn, a book abandoned on a seat or a wineglass on a table can suggest a more leisurely atmosphere.

When including people in your garden pictures, it is probably better if they do not look too posed. I prefer to picture the gardener at work, concentrating on whatever task is to hand. If you stay in a garden with your camera for any length of time, interest in what you are doing will quickly fade, and people will lose that self-conscious look that can mar a photograph. Using a zoom or telephoto lens will ensure that you do not need to get too close and encourage your subject to behave more naturally. Suggesting that they perform some garden task is another way of producing a natural picture. Suitable jobs include harvesting fruit or vegetables, cutting flowers, or bending on knees weeding.

Children can make a garden seem more animated, although they do also have a tendency to fill it with brightly coloured plastic toys, which, if you neglect to move them, may spoil any

Here, cushions and the hat left in a chair give the impression that someone is not far away.
Sigma 50mm macro lens,
Fuji Sensia (400 ISO),
1/750sec at f/4.5

99

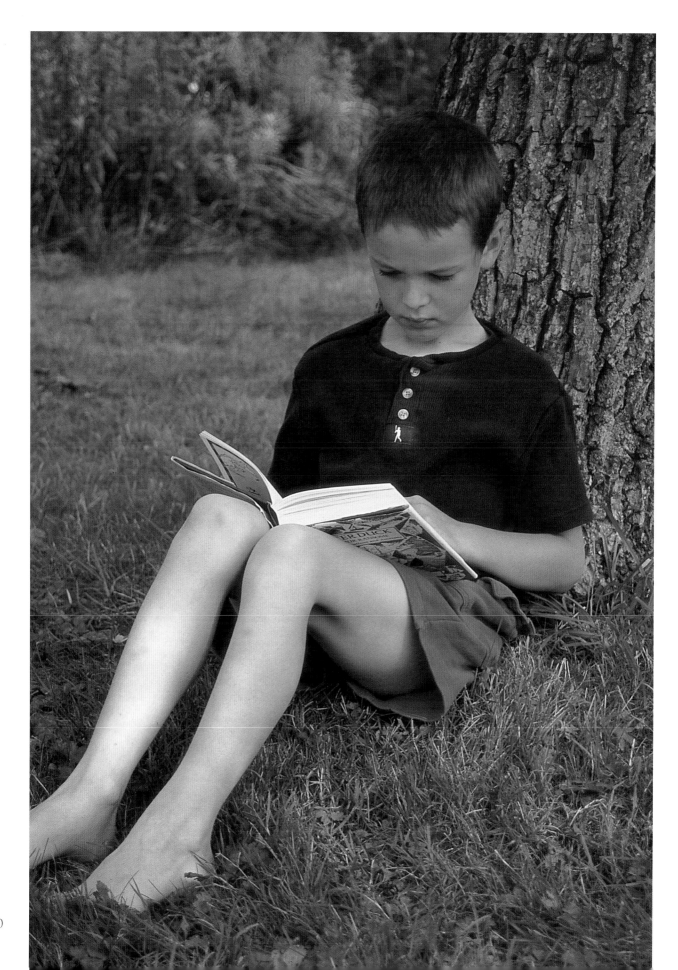

pictures you take. It is hard to stop children doing what comes naturally, so getting them to play rather than pose is rarely a problem. Indeed, it can be difficult getting them to slow down, but you can make a virtue out of this by setting a slow shutter speed to record a blurred image of the child in contrast to the surrounding static plants. When trying to achieve this effect, the camera should be mounted on a tripod to eliminate camera shake during the exposure. Alternatively, a fast shutter speed or an electronic flash can freeze movement. Panning the camera at slow shutter speeds reduces the background to blurred streaks, which gives a great sensation of movement, but little in the way of garden detail. When taking pictures of children, kneel or crouch down so that your camera is at their eye level. It is interesting how this can often give a very different view of a garden – paths between tall grasses can suddenly become mysterious, jungle-type places.

A polarizing filter has reduced reflections on the water, revealing fish below the surface.
28–80mm zoom lens, Fuji Velvia, 1/180sec at f/11

Opposite: If you let children get engrossed in a book before you take their photograph, you are more likely to get a naturally posed shot.
28–80mm zoom lens, Fuji Astia, 1/125sec at f/16

Highly contrasting light made judging exposure levels for this shot difficult. To compensate, I moved forwards so that the quilt in the central hammock filled the frame and took an exposure value from that.
28–80mm zoom lens, Fuji Astia, 1/125sec at f/16

If a garden is used for entertaining, recording some of this activity can produce very animated pictures. However, if you decide to set up your tripod you will probably only record very stilted and unnatural expressions. This is probably the one time in garden photography when you will get better pictures with a hand held camera. When the camera is hand held you will obviously need to use a faster than usual shutter speed in order to minimize the effects of camera shake. Cameras should be hand-held only at shutter speeds equal to or greater than the focal length of the lens in use. Thus a 200mm telephoto lens needs a shutter speed of around 1/250 of a second or more, but with a standard 50mm lens you could get away with a shutter speed of around 1/60 of a second.

DOMESTIC ANIMALS AND PET PORTRAITS

Wildlife such as ducks and chickens are unlikely to be found in the garden of a dedicated plant lover, but in gardens in which they are allowed free range they make very photogenic subjects. Some of the more exotic breeds of chickens have incredibly beautiful colours and markings on their feathers, and can usually be tempted to come and pose for you by using a handful of corn. Where netting has restricted the movement of birds, acceptable photographs can still be taken by positioning your lens close to the netting and using a large aperture to throw the material out of focus.

This day-old Araucana chicken makes an excellent photographic subject; seen here with its Cochin foster mother.
28–80mm zoom lens, Fuji Astia, tripod, 1/30sec at f/9.5

Larger domestic animals such as goats or horses are unlikely be in the actual garden, but the sight of such animals grazing on the other side of the fence is a visual delight that should be recorded. If the garden is home to a dog, it can be used to add character to your photographs. If you want to get the dog to look at the camera, balancing some food (such as a piece of biscuit) on the top of the lens will usually grab his attention. (Be warned that a dog which isn't well trained may grab the biscuit before you can press the shutter!) A dog asleep in the sun will give a lovely 'idle summer' feel to a picture, or, if animation is required, persuade the owner to play ball on the lawn.

While a dog can be trained to sit or lie on command, cats will only do what they choose to do. It is easy enough to photograph a cat asleep on a bench or washing itself on a

Black animals are difficult to expose for. Relying on the camera's TTL meter often results in an overexposed image, especially in sunny conditions like those seen here. For this shot, I metered from the straw and bracketed half a stop either side. 28–80mm zoom lens, Fuji Astia, tripod, 1/125sec at f/8

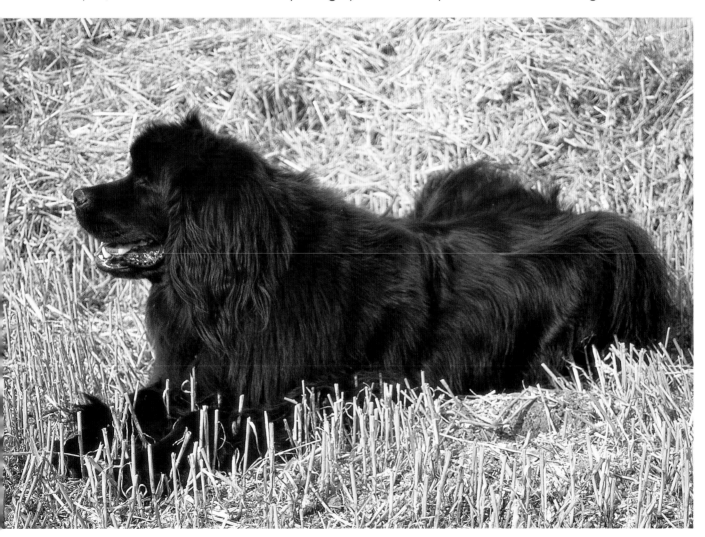

patio, but I have repeatedly failed to get a good picture of my cat walking in the garden – whenever she sees me setting up the camera she rushes across to stick her nose in the lens.

Animals grazing contentedly make an appealing sight, as long as they are on the right side of the fence.
28–80mm zoom lens, Fuji Astia, 1/180sec at f/9.5

USE OF THE SELF-TIMER

There may be times when you want to include yourself in a picture; for instance, for that 'gardener hard at work' image. This can be achieved if you have a self-timer option on your camera. You will first need to set up the shot with the camera on a tripod, taking care when looking through the viewfinder to visualize where you, as the subject, will be. It can be helpful to use an object (like a bamboo cane) of roughly your height as a stand-in at this point. Once you are ready, operate the self-timer, move into position, and pose. If using an autofocus setting, remember not to stand directly in front of the camera while you start the self-timer as this will throw off the focus.

Eyes tend to draw the viewer's
attention in animal or human
portraits, so always make sure
that they are in focus.
*28–80mm zoom lens, Fuji Astia,
tripod, 1/90sec at f/6.7*

An alternative way of taking self-portraits is to use a remote
release, although when using a cable release care must be
taken to ensure that the cable itself is not seen in the picture.
Some cameras have a built-in receiver that allows them to
operate with a wireless remote-control transmitter. These are
particularly useful for taking self-portraits. Cable-release
adapter brackets are available to fix a cable release to a
camera that does not have a cable release socket.

For this self-portrait of gardener with a basket, I set up the shot with the
basket on a crate. Having started the self-timer, I had time to grab the handle
and kick the crate out of the way before the picture was taken.
28–80mm zoom lens, Fuji Velvia, tripod, self-timer, 1/45sec at f/5.6

WILDLIFE IN THE GARDEN

BIRD AND MAMMAL VISITORS.

BUTTERFLIES AND OTHER INSECTS.

THE GARDEN POND.

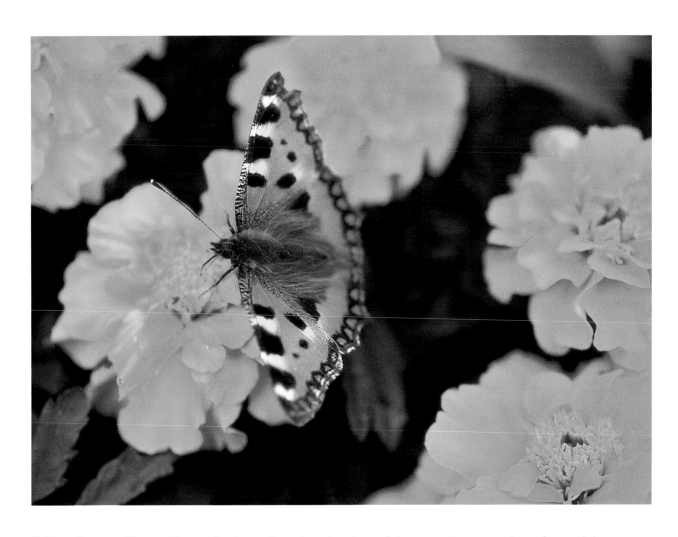

Taking pictures of butterflies can be frustrating when they keep flying away just as you have focused the camera. The best opportunity to capture one usually comes when they are feeding, as here.
28–80mm zoom lens, Fuji Velvia, tripod, 1/125sec at f/9.5

A garden would seem a sterile place without bees bumbling around the lavender, butterflies flitting between the flowers and birds singing from the trees. Even if it is not a particular interest of yours, including some garden wildlife will add an extra dimension to your photographs. Wildlife photography is of course a very popular subject in itself, and there is undoubtedly no better place to start than in a garden where the birds and animals are easily accessible and will be accustomed to the presence of people.

BIRD AND MAMMAL VISITORS

The idea of the wildlife garden is probably more popular than ever before, with many people adapting their gardens to make them more in tune with the needs of indigenous wildlife. A steady stream of different birds visits even small urban gardens, and some can become quite tame, particularly if fed regularly. For less trusting subjects, you can use the potting shed, other outbuildings or even the house as a bird hide. A surprising number of different species may be seen, especially if there is a bird table, nesting boxes or water close by.

Even though they ruined a new planting of trees in our orchard, I still find fallow deer irresistible. You may need to use a fast film to capture such subjects, particularly in poor light.
80–200mm zoom lens, Fuji Provia (400 ISO), 1/250sec at f/11

Moles or, as here, Prairie dogs, may play havoc with your lawn, but if they help to produce a good photograph they may perhaps be forgiven. *80–200mm zoom lens, Fuji Provia (400 ISO), 1/125sec at f/5.6*

Perhaps the most important quality for a wildlife photographer is patience. While you may be lucky and find a suitable subject posing for you when you have your camera at the ready, photographing wildlife is rarely as straightforward as taking plant portraits – a plant may cause frustration by blowing about in the wind, but at least it is not going to fly or run away. You are far more likely to be able to take successful photographs if you are familiar with your subject and have spent some time observing its behaviour. Once you have an understanding of its habits as regards feeding, bathing, the guarding of territory and so on, you will find it easier to decide how to photograph it.

For all but the tamest of subjects, the telephoto lens is probably an essential piece of equipment. As discussed earlier (see page 27), telephoto lenses have the effect of magnifying the image, thereby making things appear closer than they really are. A 300mm telephoto lens, for example, has a focal length that is six times greater than that of the standard 50mm lens and will magnify the image by six times. Obviously, this enables you to get an image of a reasonable size without having to get too close to your subject. Lenses with focal lengths greater than 300mm are used by many serious wildlife photographers – a 600mm lens may be needed when photographing a wary subject – but there are disadvantages with such lenses, not the least being the cost. Also, lenses with a focal length of 400mm or more are quite long and unwieldy, and their high magnification exaggerates camera movement. Make sure the camera is firmly attached to a

tripod or, if using the house or shed as a hide, you may be able to support the camera and lens with a beanbag resting on a windowsill.

Most garden mammals are, like birds, understandably wary of humans, although some – such as grey squirrels – can be remarkably tolerant, particularly when they are looking for food. Squirrels only visit my garden in the autumn, a sure signal that our walnuts are ready. We do, however, have a fluctuating population of rabbits. I find rabbits extremely photogenic, especially when they are washing themselves, but they are very alert and it takes a lot of stealth and patience to photograph them. Of course, one person's idea of a photogenic garden subject is another person's garden pest.

It is possible to take reasonable wildlife shots through a window if you position the lens close to the glass. The extra layer of glass will reduce the amount of light reaching the camera and make longer exposures necessary. Obviously, you need to make sure that the glass is clean and free from smears.

BUTTERFLIES AND OTHER INSECTS

Throughout the warmer months there are many insects that can make appealing subjects. Few insects are as spectacular as some butterflies, which will often make particularly dramatic pictures as they pose obligingly on a flower. Butterflies and the majority of other insects are generally most active in the warmer parts of the day when strong lighting can make photography more difficult. Better pictures will be obtained on bright but overcast days. If the weather is too dull and cold you are more likely to find the butterflies resting in a hedge with their wings closed.

Shots of insects in flight can be taken with a shutter speed of around 1/500 of a second, which is fast enough to freeze the movement. Shots like this should be compared with pictures taken at a slower shutter speed of around 1/90 to 1/125 of a second. The latter will give a blurred image that emphasizes motion.

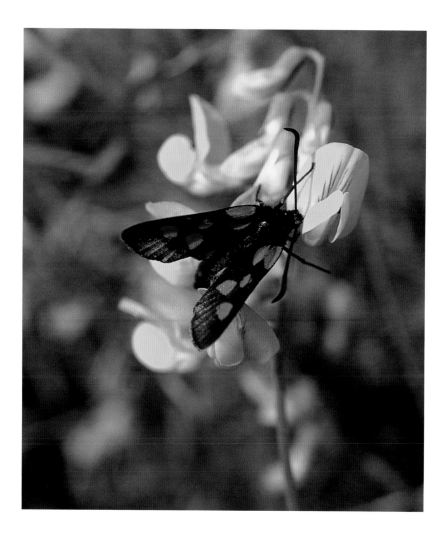

This day-flying Burnet moth
posed obligingly for several
minutes while feeding, allowing
plenty of time to compose this
close-up shot.
Sigma 50mm macro lens,
Fuji Astia, 1/250sec at f/22

If you want to take close-up pictures of butterflies, bumblebees, ladybirds and so on, a macro lens is most useful. Macro lenses are optically corrected to give their best results at close range. For insect work, a telephoto macro lens with a focal length of around 100mm is the most useful as it allows a reasonable working distance between the subject and the lens. For high magnifications when using a 50mm macro lens, it is necessary to get very close to the subject. This may scare the subject off, and may cause you to block out too much light.

One of my favourite insect subjects is the dragonfly. There are many different species, often with spectacular, almost metallic colouring. Although they are found chiefly in damp areas, some will travel far in search of midges and other tiny insects, and they will often perch obligingly on the top of bamboo canes. If the garden you are photographing has a pond, keep a look out for newly emerged dragonflies on the surrounding vegetation.

THE GARDEN POND

A pond is often an extremely rich wildlife habitat and may attract amphibians such as frogs, toads and newts in large numbers. Frogs and toads are usually quite easy subjects, as they will let you approach closely. When taking pictures of the pond itself, use a polarizing filter to remove distracting glare from the water surface. Remember that the filter operates by refracting light, and in doing so will reduce the light reaching the film. Longer exposures by up to two f-stops may therefore be necessary.

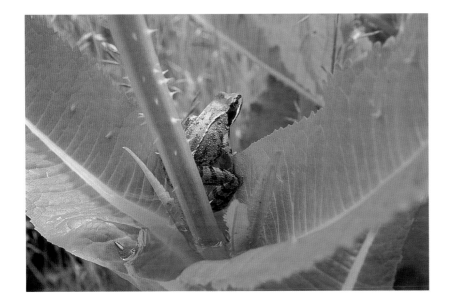

Teazel plants usually have a reservoir of water between their leaf bases. This frog found one reservoir to be an ideal bath and hunting ground, demonstrating that common subjects can be found in unusual places.
Sigma 50mm macro lens,
Fuji Astia, 1/125sec at f/22

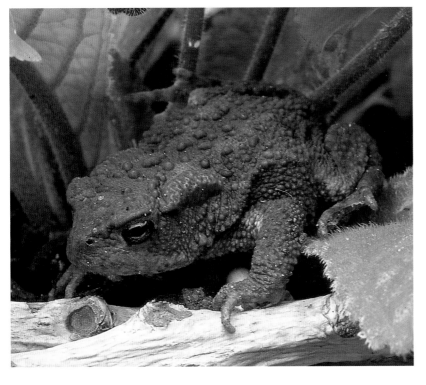

Using a macro lens has enabled me to get close enough to focus on the wonderfully textured skin of this toad.
Sigma 50mm macro lens,
Fuji Astia, 1/60sec at f/45

PLANT PORTRAITS
AND PARTNERSHIPS

LOOKING AT PLANTS, INDIVIDUALLY AND IN COMBINATION.

DETAILS MAKE THE DIFFERENCE.

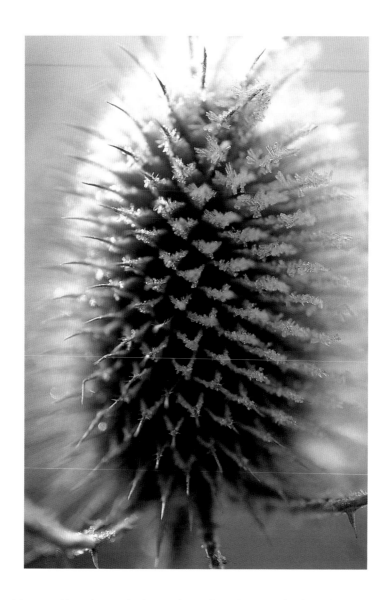

Filling the frame with this teazel head reveals the sculptural qualities picked out by a heavy frost.
Sigma 50mm macro lens, Fuji Astia, 1/10sec at f/45

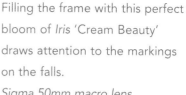

It is all too tempting when entering a garden to grab your camera and start snapping at the first thing that catches your eye. However, good gardens are the result of careful planning and skilful plant combining on the part of the gardener, and the photographer too will achieve more pleasing results by approaching the task sensitively.

Filling the frame with this perfect bloom of *Iris* 'Cream Beauty' draws attention to the markings on the falls.
Sigma 50mm macro lens,
Fuji Astia, tripod, 1/60sec at f/19

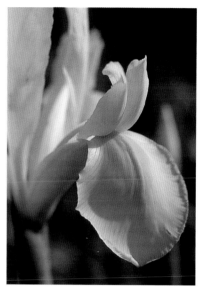

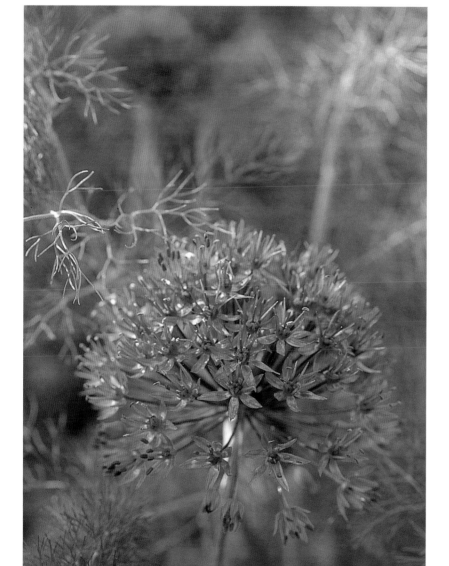

The vivid scarlet of *Papaver orientale* 'Sindbad' is made all the more dramatic against the green of this meadow setting.
Sigma 50mm macro lens,
Fuji Astia, tripod, 1/30sec at f/5.6

This strongly shaped *Allium* 'Purple Sensation' contrasts well with the feathery fronds of bronze fennel. Gentle side lighting helps to emphasize the varied textures.
28–80mm zoom lens, Fuji Astia, tripod, 1/30sec at f/22

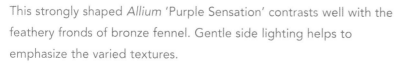

LOOKING AT PLANTS, INDIVIDUALLY AND IN COMBINATION

If you are photographing a garden that you know well, you will already be aware of the most successful plantings and will perhaps know at which times of day the light is best in each part of the garden. Even so, it is worth walking around holding your

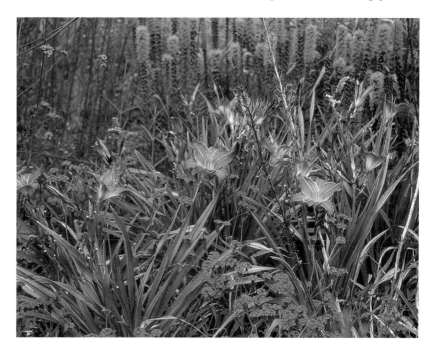

This careful blend of coordinating colours is featured at the garden of Green Island in Ardleigh, Essex, England. *28–80mm zoom lens, Fuji Astia, 1/90sec at f/11*

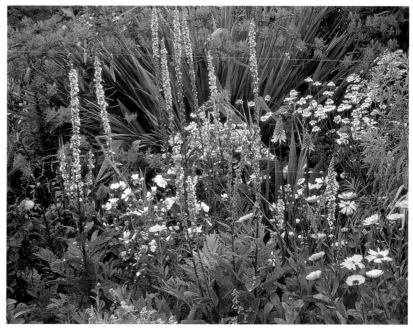

Hot red, orange and yellow colours always attract attention, as in this border at The Harralds in Norfolk, England. *28–80mm zoom lens, Fuji Velvia, 1/90sec at f/9.5*

camera and looking at areas of interest through the viewfinder, as this can sometimes draw your attention to an image that you would not normally have noticed. If the garden is new to you, leave your camera in its case at first, and walk round making a note – mentally or on paper – of points of interest. Be aware of the light and how it changes; dark cloud cover may be a blessing if it shields the sun long enough for you to take your picture without strong shadows, but it may mean that you need to cover your equipment quickly if it starts to rain.

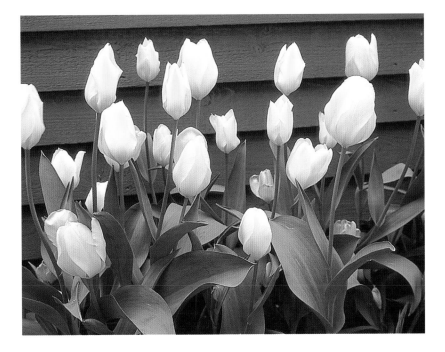

To prevent overexposure, white flowers such as these creamy *Tulipa* 'Purissima' are best photographed in diffused light.
28–80mm zoom lens, Fuji Astia, 1/180sec at f/8

Spiky plant foliage makes an effective contrast with the rounded pots at Highfields Farm, Bures, England.
28–80mm zoom lens, Fuji Astia, 1/60sec at f/19

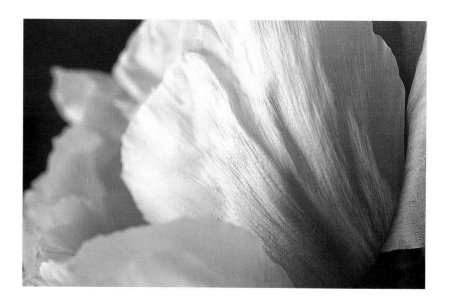

Moving in close allows this image to concentrate on the silky texture and feminine pink of the petals of *Paeonia suffruticosa* 'Yachiyo-tsubaki' (Syn. Eternal Camellias). *Sigma 50mm macro lens, Fuji Astia, 1/60sec at f/8*

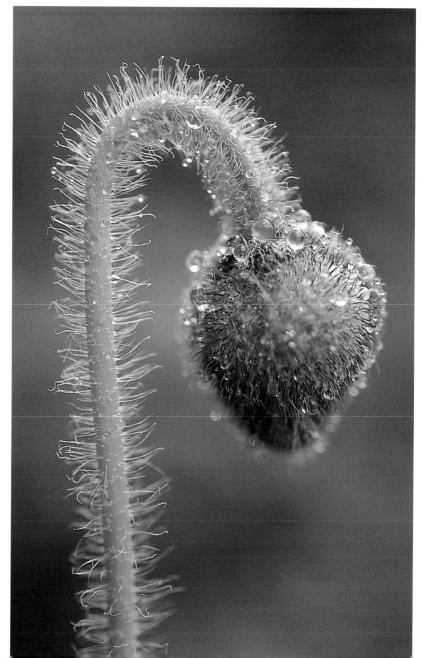

Even in bud, with its gracefully nodding head and amber-coloured hairs this poppy has a lot of interest. Setting a small f-stop has blurred the background. *Sigma 50mm macro lens, Fuji Astia, tripod, 1/125sec at f/2.8*

When taking a plant portrait, make sure that you have chosen a pleasing specimen. Chewed petals, diseased leaves and flowers that are past their best may be excused in the context of a garden full of flowers, but will make for a poor close-up photograph, unless you intend this damage to be symbolic. Consider the background to your chosen subject: one plant neighbour may be more pleasing than another. Walk around and look from every angle, including both high and low viewpoints. A simple background usually works best as it enables the subject to stand out more clearly. If, however, the background is too distracting, you can set a large aperture on the lens so that when you focus on the flower the background will be blurred.

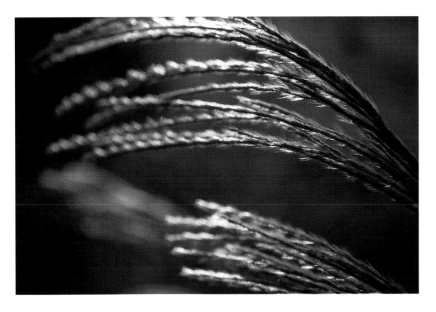

The monochrome-style look of this picture of miscanthus plumes blowing in the wind was achieved by photographing into the light.
Sigma 50mm macro lens, Fuji Astia, tripod, 1/180sec at f/4

Filling the frame with the leaf of *Boesenbergia longiflora* demonstrates the beautiful veining.
Sigma 50mm macro lens, Fuji Velvia, tripod, 1/30sec at f/9.5

Carefully check for distractions that could spoil the picture. A bumblebee visiting your chosen flower may create a pleasing image, whereas a fly settling on a white flower may not. Plant labels can be a particular problem, especially the white plastic ones, which, if used to excess, give a tombstone effect. Obviously, if you are in your own garden you can temporarily remove labels, but this will cause great annoyance in other gardens. Ask the owner's permission before moving any labels, or try moving foliage to hide them or pushing them discretely into the soil (as long as you return them to their original depth when you have taken your picture).

This line of seakale pots makes a strong composition.
28–80mm zoom lens, Fuji Astia, 1/20sec at f/6.7

Vary the composition and the viewpoint so that you take both vertical and horizontal images, and try unusual angles. A low viewpoint allows you to look up into the nodding flowers of hellebores and fritillaries, whereas standing on a bench or looking down from a window could reveal a tapestry-like effect in dense plantings. Many plants form their own natural composition. For example, sculptural shapes like the rosettes of sempervivums and echevarias make very effective close-up pictures.

This highly original bench is an amusing addition to an art lover's garden, and makes an interesting and unusual photographic subject.
28–80mm zoom lens, Kodachrome 64, 1/60sec at f/9.5

For a sharp image, use a small aperture. An f-stop of at least f/16 will ensure that your main subject is in sharp focus, but remember that setting a small aperture will make slow shutter speeds necessary. If your camera has a depth-of-field preview button, you can use it to check how much of the image will be focused. When composing your picture, especially close-ups, always use a tripod. Use of a remote release cable or self-timer will eliminate any vibration that would result when manually pressing the trigger, and is important when slow exposures are used.

Moverons at Brightlingsea in Essex, England, has many unusual specimens to interest the plant lover. This is the autumn-flowering *Liriope muscari.*
28–80mm zoom lens,
Fuji Velvia, 1/45sec at f/11

Gardens can be full of interesting non-flowering details, like this little lantern by a wattle hurdle.
28–80mm zoom lens, Fuji Velvia, 1/60sec at f/13

Standard and telephoto lenses are quite capable of producing moderate close-up images of, for example, peonies or delphiniums, but if you want greater magnification to illustrate the detail of a snowdrop, you need to use either a close-up attachment or a macro lens. I prefer to use a macro lens. They are more expensive, but enable very close focusing and can be used in conjunction with extension tubes to give extreme close-ups of life-size or larger.

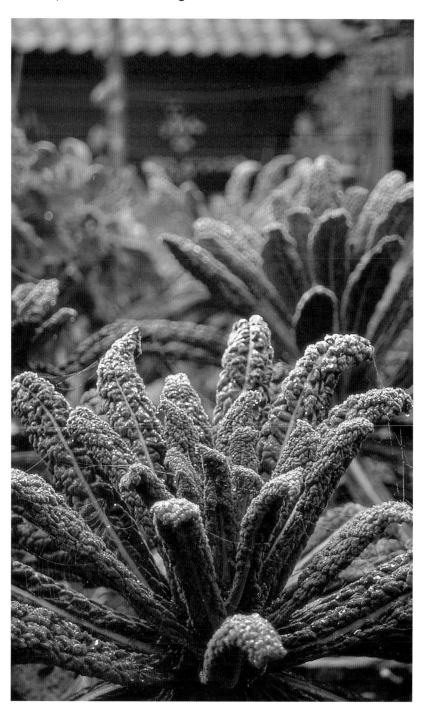

Do not ignore vegetable gardens as a source of interesting pictures. Even in November this 'Nero di Toscano' kale looks attractive. *Sigma 50mm macro lens, Fuji Velvia, tripod, 0.7sec at f/27*

This sundial image was snatched between heavy rain showers, proving that you do not need to wait for a dry, sunny day to take your garden pictures.
28–80mm zoom lens, Fuji Astia, 1/60sec at f/6.7

By contrast, this sundial was photographed on a bright, sunny day. Even a grey graduated filter was unable to balance out the contrasting light levels between the two halves of the picture.
28–80mm zoom lens, Fuji Velvia, polarizing filter, grey graduated filter, 1/60sec at f/6.7

Hydrangeas add rich late-summer colour to this part of the garden at High Hall, Nettlestead, in Suffolk, England.
28–80mm zoom lens, Fuji Astia, 1/60sec at f/13

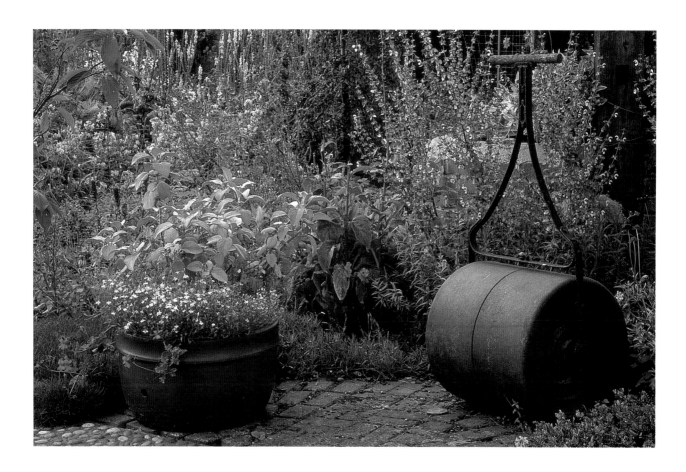

Underexposing by half a stop ensured that the rich detail in this image was not lost.
28–80mm zoom lens, Fuji Velvia, tripod, 1/4sec at f/22

When recording plant partnerships, look for good colour combinations. Some people favour soft colours together, such as pink roses against powder-blue delphiniums. Other gardens are full of more rigorous colour, with tropical red next to fiery orange. A zoom or telephoto lens is often helpful here, as you can make the flowers appear closer together.

You do not have to look at the floral elements of a garden alone; even this wheelbarrow looks attractive when contrasted with the different textures of brick and gravel.
28–80mm zoom lens, Fuji Velvia, tripod, 3secs at f/27

White gardens, made famous by the one at Sissinghurst in Kent, England, are probably less popular than they were, but still have a their fans. White flowers have a tendency to 'burn-out' (i.e. overexpose) in a photograph and can be difficult to expose correctly. It is preferable to photograph white flowers and silver foliage in diffused light, and try to underexpose by half to one f-stop. Ultimately, to be sure of getting a good picture it is worth bracketing your exposures. Remember that green is a colour too and do not ignore foliage, particularly leaves with interesting shapes or textures such as feathery fennel or the gloss of many evergreens.

As well as looking at colour combinations, plant form is important. Consider the verticals of iris leaves against the soft rounded shapes of peonies. Spiky plants such as yuccas and cordylines stand out well against more fluid grasses. Some plants have a naturally architectural form; for example, the

A well-manicured lawn makes a brilliant foil to contrasting foliage colours and a blue sky.
28–80mm zoom lens, Fuji Velvia, polarizing filter, 1/60sec at f/6.7

These bryony berries are an
attractive feature of a wildlife
hedge, made all the more so
by raindrops.
Sigma 50mm macro lens,
Fuji Astia, tripod, 1/45sec at f/5.6

pencil-like slimness of an Italian cypress or the pendulous
habit of birch or weeping willow. The strong geometric shapes
of much topiary work just beg to be photographed, while
some of the more whimsical topiary forms can be used to add
a note of humour to your pictures.

DETAILS MAKE THE DIFFERENCE

It is often the details of a garden that define its uniqueness.
Look around and try to establish the particular interests of the
gardener. The wildlife enthusiast may have a patch of nettles
to attract butterflies or a profusion of bird boxes to encourage
nesting. Those more interested in plants may amass
collections of special groups of flowers, and alpine enthusiasts
can be identified by trademark stone troughs or a glasshouse
packed with miniature vegetation. These themes can be used
as signatures, giving the garden a strong sense of identity.

Details of bark, particularly when they are covered
with lichens, can make an interesting study.
Sigma 50mm macro lens, Fuji Astia, tripod,
2secs at f/45

Diffused light and Fuji Velvia transparency film
emphasize the rich green of the moss growing in this
flint path.
Sigma 50mm macro lens, Fuji Velvia, tripod,
3secs at f/45

Pay regard to the use of local materials in the hard landscaping, such as slate paths, flint walls or wattle hurdles. Modern materials, such as aluminium planters or crushed-glass mulches, often have strongly reflective qualities. (Using a polarizing filter will ensure this does not dominate your photographs.) Architectural features like walls, arbours, decking and furniture are relatively permanent, and often reflect the taste and personality of the gardener. Garden ornaments such as pots and statues may establish a sense of originality or even eccentricity. Whether formal or quirky, these details can really make a difference.

Do not put your camera away at dusk. These little candles have cast an appealing light on the pyracantha berries.
28–80mm zoom lens, Fuji Sensia (400 ISO), tripod, 4secs at f/16

A dusting of frost or snow can make all the difference to detailed images. Here, the pattern of pantiles on our garage roof is highlighted.
80–200mm zoom lens, Kodachrome 64, tripod, 0.7sec at f/22

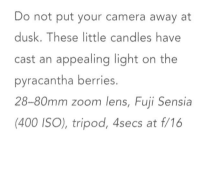

If you are taking pictures after dark, remember that you may need to use a faster film, especially if you plan to include people in your image.
28–80mm zoom lens, Fuji Sensia (400 ISO), tripod, 1/2sec at f/5.6

THE GARDEN THROUGH
THE SEASONS

RECORDING THE EFFECTS OF THE CHANGING SEASONS.

PHOTOGRAPHING SNOW, FOG, RAIN AND BRIGHT SUNSHINE.

A GARDEN PROJECT.

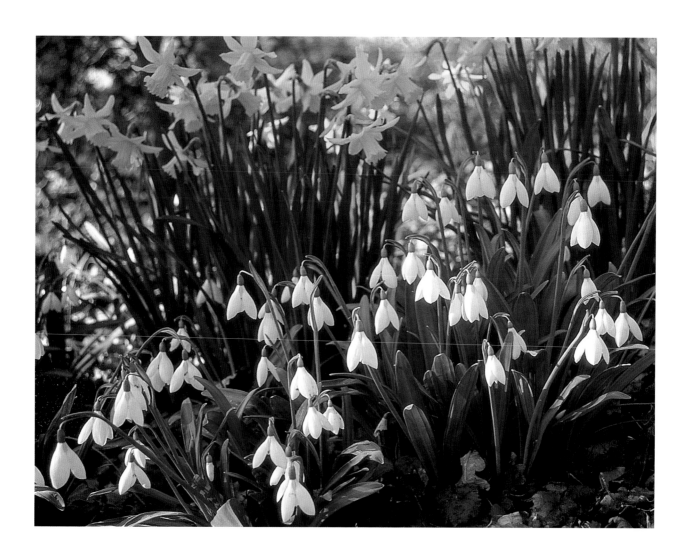

The first bulbs to flower are a welcome sign that spring is on its way – a moment worth capturing on film.
28–80mm zoom lens, Fuji Astia, tripod, 1/60sec at f/11

RECORDING THE EFFECTS OF THE CHANGING SEASONS

Garden photography should not begin and end in the summer. In every season, and in any weather, there are pictures to be taken. An interesting way of recording the changing seasons is by taking a sequence of photographs of an individual tree or shrub. A cherry tree such as *Prunus sargentii* has clouds of pink blossom in spring followed by strong form and green foliage in summer. Later, autumn colours in shades of gold and orange fall to reveal appealing glossy bark in winter, when frost and snow may add to the sculptural effect of bare branches. The tree could be recorded in isolation or offset to the side of your picture to show how companion planting varies through the year. Alternatively, you could show the seasonal change in an arrangement of containers (as seen here).

When shooting a sequence of a whole garden or border, you need to ensure that there is a strong focal point that can be readily identified at each season, such as a seat or statue. Without this the viewer may not recognize the link between the pictures and the impact of the sequence will be reduced. It helps if you can take the photographs from the same spot each time you return. A border sequence might show a progression from spring bulbs and summer exuberance, to warm autumn colours in the purples of asters and reds and golds of rudbeckias and heleniums. Winter might reveal skeletal plants rimmed with frost, seed heads, evergreens and the brilliance of jewel-like winter bulbs.

The collection of ornamental pots outside our front door has a changing variety of plants to reflect the seasons.
Spring
Sigma 50mm macro, Fuji Astia, 1sec at f/45

Summer
Sigma 50mm macro, Fuji Velvia, reflector, 1/60sec at f/9.5

Autumn
Sigma 50mm macro, Fuji Velvia, 1/45sec at f/11

Winter
Sigma 50mm macro, Fuji Astia, 0.7sec at f/27

129

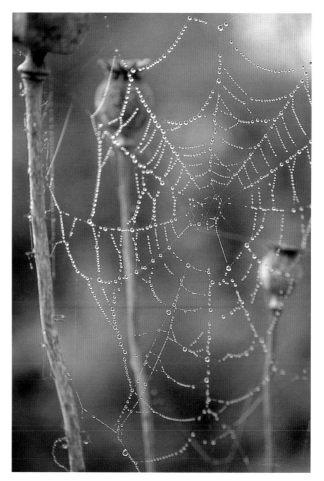

Summer is usually a time of bright colours and intense light. This basket of scarlet pelargoniums looks particularly effective against the white windows.
28–80mm zoom lens, Fuji Astia
1/60sec at f/9.5

Always look for unexpected combinations. Here, autumn's seed heads are complemented by a cobweb decked with dew.
Sigma 50mm macro lens, Fuji Velvia, tripod,
1/15sec at f/2.8

PHOTOGRAPHING SNOW, FOG, RAIN AND BRIGHT SUNSHINE

Snow is not usually something that you can plan for, and it can melt all too quickly as the sun comes up. It does, however, create magical effects in the garden, accentuating the form of architectural elements and smoothing over a degree of scruffiness. Low winter light falling on snow can create a stark monochrome image. When recording a garden under snow take any broad views you require first before closing in to

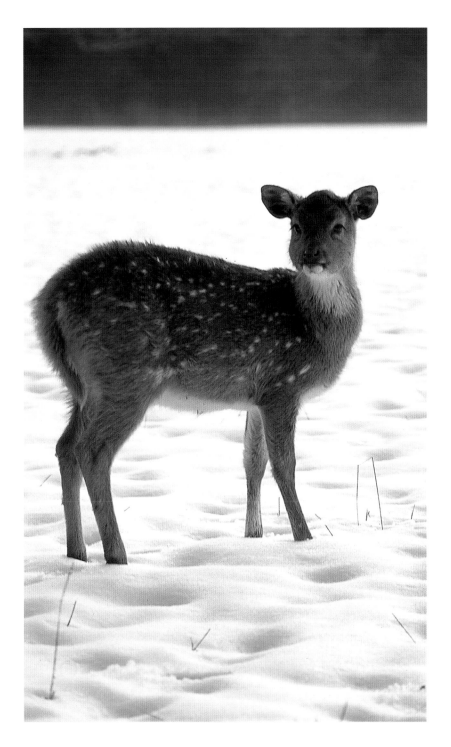

The fruits of *Iris foetidissima* last for most of the winter and look best when dusted with snow.
Sigma 50mm macro lens, Fuji Astia, tripod, 2secs at f/32

Even exposing this image for two stops more than suggested by the camera's light meter has left the young fallow deer underexposed slightly. However, increasing exposure still further would have caused the snow to 'burn out', making a less appealing picture. Getting the balance right can be quite difficult, so be sure to bracket your exposures in such situations.
80–200mm zoom lens, Fuji Provia (100 ISO), 1/250sec at f/8

We don't often get to experience a white Christmas in Suffolk, England, so the event could not go unrecorded.
28–80mm zoom lens, Fuji Velvia, tripod, 1/30sec at f/9.5

smaller details. This ensures that your own footprints do not detract from your pictures. The footprints of bird and animal visitors, on the other hand, can make interesting patterns that are subjects in themselves.

When the sky is bright, reflected light from a covering of snow can easily confuse your camera's light meter. The high light intensity often gives a falsely high meter reading and images may come out too dark. An extra exposure of one or two f-stops will usually compensate for this, but you will find it useful to bracket your exposures in order to make certain you have at least one perfectly exposed image. The reflected light will not affect incident light readings taken with a hand-held meter, but in very bright conditions you may need to reduce the suggested exposure by one to one-and-a-half stops to maintain detail in the highlights. When photographing in very cold conditions, be sure to carry a plentiful supply of camera batteries – they do not last as long as usual when cold. If you keep the spares in a shirt or trouser pocket, your body heat should keep them warm enough to maintain their function.

Mist and fog give an eerie, mysterious atmosphere to pictures. Rising early-morning mist can be particularly atmospheric, giving a soft feel and pastel colours to pictures. Thick fog is sometimes recorded on film with a slight bluish cast to it, but it is possible to whiten the scene by overexposing the image by a half to one stop.

It is tempting to use rain as an excuse to leave your camera in its bag and sit at home with a nice cup of tea. However, taking pictures in light rain or drizzle can give the resulting photographs a luminance that is very appealing. In particular, I enjoy those slate-grey brooding skies that form an effective backdrop to golden autumn foliage. Most modern cameras can cope with short exposure to rain, but you should wipe all equipment dry as soon as possible and keep it covered when it is not actually in use. Keep some lens tissues to hand to wipe away any raindrops that fall on the lens. Of course, you can take advantage of garden buildings or the house itself to keep yourself and your camera dry while photographing through an open window or door.

Fog has provided a grey backdrop to the sculptural form of these teazels. Increasing exposure by a half to one stop will whiten fog.
28–80mm zoom lens, Fuji Astia, tripod, 1/60sec at f/11

This fennel plant looks particularly attractive with raindrops clinging to the fronds.
28–80mm zoom lens, Fuji Velvia, tripod, 1sec at f/16

Looking through racks of picture postcards at many tourist spots gives the impression that photography should only be done in bright sunshine. While excellent images can indeed be produced in such conditions, all too often the film is unable to cope with the degree of contrast involved, resulting in pictures that combine areas of overexposure with dull black shadow.

Pictures of strong colours can look very effective in these conditions, but try to compose the image so that areas of shadow are excluded. The use of a polarizing filter will

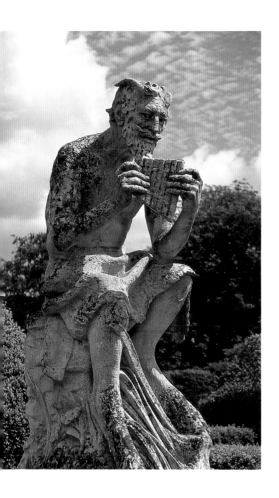

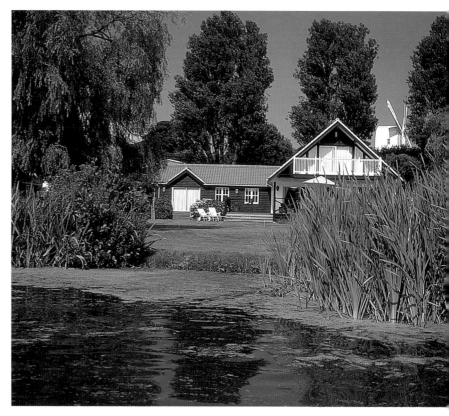

A polarizing filter was used to enrich colours and reduce glare from the water in this scene, which was taken in bright sunshine.
28–80mm zoom lens, Fuji Velvia, 1/90sec at f/16

Look at the difference between the sky in the right and left halves of this picture of Pan at Godinton House, England. The broken cloud on the right makes for a more attractive picture. It is always worth waiting until conditions improve, or trying to change your position, if this will create a better photograph.
28–80mm zoom lens, Fuji Astia, 1/60sec at f/16

enhance the colours and reduce distracting glare, and a UV filter is recommended to reduce haze. Another filter that may be helpful in high-contrast situations is a light-grey graduation filter. This, when placed in front of the lens and aligned with the brighter half of your picture such as a light sky, tones down extreme contrasts between the sky and your subject. When including the sky in your pictures pay attention to the clouds; an interesting, balanced cloud formation can transform an ordinary photograph into an arresting image.

A GARDEN PROJECT

As anyone who has ever watched a garden makeover programme on television will know, before and after images of work done in a garden can be quite compelling. Indeed I once visited a garden where a display of before and after photographs was attracting more interest than the garden itself.

Documenting the progress of a garden restoration project is obviously of more importance for a historic garden, but even owners of small gardens will get much pleasure from a record of their pet project. Take pictures before work starts on the project and fairly frequently as it progresses. Also, try to include portraits of the people involved; even if the work is not being done by the stars of a television series, the personalities involved can make any building or landscaping job enjoyable, or otherwise. On completion, show the results in use.

The creation of a circular patio in our garden required the combined talents of a labourer and a skilled craftsman, and these shots demonstrate how easily a garden project can be recorded for posterity.
28–80mm zoom lens, Fuji Astia

135

OTHER PEOPLE'S GARDENS

GARDENS TO VISIT.

LEGAL ASPECTS.

This inviting seat is at Columbine Hall in Suffolk, England.
28–80mm zoom lens, Fuji Astia, 1/60sec at f/9.5

GARDENS TO VISIT

If yours is a garden of detail, with a wide range of planting, you will find it a never-ending source of photographic inspiration. However, there may be times when you feel the urge to pack up your camera and visit another garden to look for new ideas or just to spend a pleasant afternoon enjoying the results of someone else's labour. There are numerous gardens open to the public, sometimes on a regular basis, or perhaps just once a year for charity. In England and Wales, the National Gardens Scheme lists some 3,500 gardens in its famous yellow book. The United States, Scotland, Belgium, the Netherlands, Australia and Japan have similar schemes, and many other charity organizations produce lists of gardens open, perhaps just within a local area.

The wonderfully natural woodland garden at Blakenham, in Suffolk, England, is open regularly throughout spring in aid of the National Gardens Scheme.

80–200mm zoom lens, Fuji Astia, 1/2sec at f/22

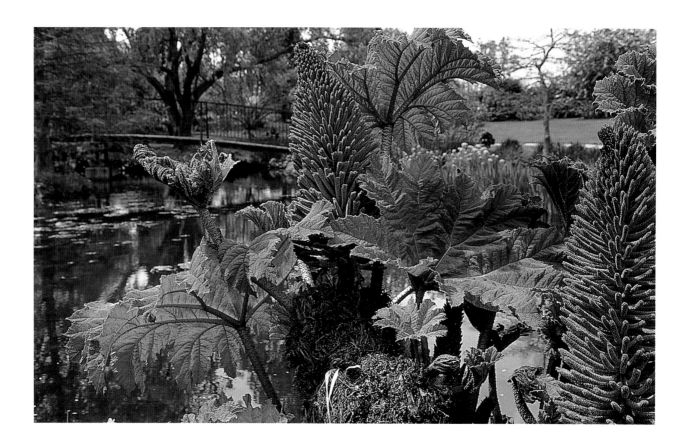

The dramatic sculptural look of *Gunnera Manicata* makes an impressive foreground feature in this view at the Royal Horticultural Society's garden at Hyde Hall in Essex, England. *Sigma 50mm macro lens, Fuji Velvia, 1/45sec at f/16*

Joining a local, national or indeed international horticultural society is a good way to meet other keen gardeners, and many such societies arrange visits to gardens that are not normally open to the public. There are societies that specialize in just one particular group of plants, and also those such as the Cottage Garden Society that favour a certain style of gardening. Before travelling on holiday it is worth contacting a horticultural society to see if they can give advice on gardens open in the area you will be visiting. The Internet is a useful source of information on which gardens to visit, and it is even possible to go on 'virtual tours' of some gardens.

The vast majority of those gardens that are open to the public will permit hand-held photography free of charge, provided that the images are intended for your own personal use. For commercial photography, you must seek permission first. Some gardens, for example those of the Royal Horticultural Society in England, request a donation towards the upkeep of the garden from both professional and amateur photographers, which is fair enough when you remember the considerable costs involved in maintaining a garden to a high standard.

If you wish to use your tripod, check first whether this is permissible – some owners may be understandably concerned about having tripod legs placed in their borders or blocking the pathway for other visitors. Obviously, you must remember that working in someone else's garden is a great privilege. Do not do anything to make the owner regret your presence, such as moving labels or plant material, without asking first.

LEGAL ASPECTS

Laws on privacy vary greatly between countries – and between states in the United States – and generally they apply to taking photographs of people rather than gardens. There have been calls for new privacy laws in England that would outlaw the photographing of people without their consent, but it was the Human Rights Act that was used in the case of Michael Douglas and Catherine Zeta-Jones against *Hello* magazine. This Act declares that 'everyone has the right to respect for his private and family life, his home and his correspondence', and it could conceivably be argued that your garden is an extension of your home. Remember that to go into a garden that is not specifically open to the public (or outside of opening hours) without permission would be regarded as trespassing. Consider too that, particularly in foreign countries, cameras may on occasion be viewed with suspicion. Hopefully, taking a picture of a garden would never end in serious trouble, but if in any doubt it would be wise to leave your camera in its bag.

Despite these warnings, gardeners are often generous people by nature and most are happy to allow you to photograph their garden. However, I do feel that it is a good idea to offer prints of the photographs that you have taken or perhaps a special plant as a token of your appreciation.

Twisted buxus stems make an appealing natural frame for a glimpse of the garden at Dowcra's Manor in Cambridgeshire, England. *Sigma 50mm lens, Fuji Velvia, 1/30ec at f/8*

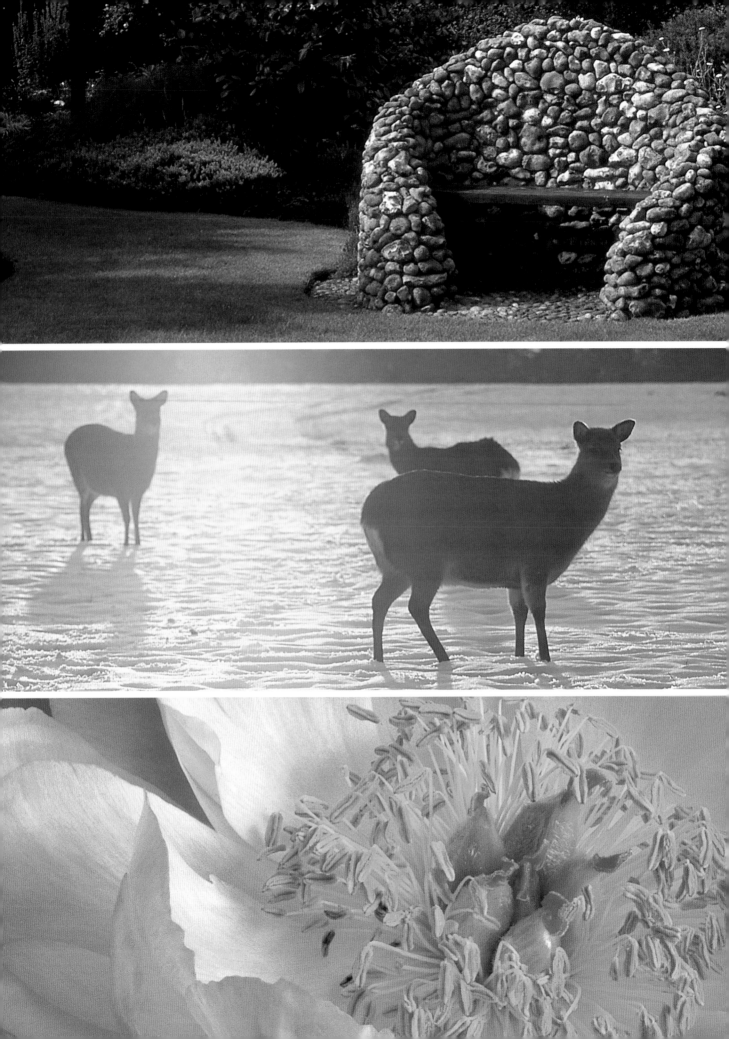

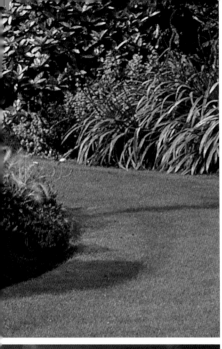

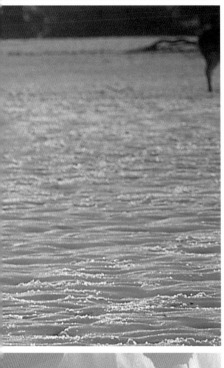

ADDITIONAL
CONSIDERATIONS

Photographing
your garden

ARCHIVAL AND DISPLAY OF YOUR WORK

STORAGE.

DISPLAY IN ALBUMS, FRAMES AND PHOTOMONTAGES.

DIGITAL IMAGES.

Enlarged, framed and hung on your wall, or projected onto a screen to be admired by members of your local horticultural society – however satisfying it is to have your pictures on display, it is important to find a way of storing those you cannot use immediately.

STORAGE

Whether your images are in the form of prints, transparencies or digital files, the principles of storage are the same. You must be able to file them with the minimum of effort, or the temptation will be to shove packets of prints and boxes of slides into the back of a cupboard, and to delete digital images rather than download them. Retrieval must be equally easy so that you know what images you have and where they are,

There is a wide variety of albums and storage systems available for prints and slides.

and so that they are easy to access and view. With slides and prints there will inevitably be a gradual loss in image quality over time. To delay this, they should be stored in dry conditions and at a stable temperature, ideally less than 21°C (70°F). Avoid the use of paper and cardboard that contains acid; acid-free paper is available from most art shops.

Before storing your images, go through them and edit them ruthlessly. There is no point in wasting storage space on a second-rate image, but be aware that some images can be salvaged. Cropping an image may improve its composition, and modern digital technology means that even out of focus and wrongly exposed images can be corrected to a large degree using software such as Adobe Photoshop. However, do consider whether you think the final image will be worth the time and effort spent in manipulating it digitally. A graphics tablet (a cordless digital art pad) is a useful accessory to make digital manipulation easier.

Opposite: Prints of your images can be framed and displayed on your wall.

Home computers, with the appropriate software, make the printing of labels for slides a very simple (though still time-consuming) business.

A simple filing cabinet can store thousands of slides.

If you are going to buy a light box, it is worth investing in a large one to make viewing and sorting through collections of transparencies easy.

Cataloguing your images is very useful. You can use a card index or set up a computer database. Make sure that your pictures are captioned to suit your needs, including the botanical names of plants featured, where and when it was taken, and so on. Additionally, giving each image a unique title or number will make finding it easier. Your cataloguing system should allow cross-indexing if an image could be filed under more than one category. Remember, though, that if you include too much information in your database, you will spend forever filling in records.

DISPLAY IN ALBUMS, FRAMES AND PHOTOMONTAGES

Prints can be stored in albums or boxes. The most widely available albums include those with self-adhesive pages or slip-in style panels, and traditional albums with glassine interleaves. Plain-coloured classic-styled albums are probably best if you want to use them to display as well as store your prints, and loose-leaf albums make it easier to organize your images. Specific albums are available for the APS system, which hold prints from five to ten films plus their index sheets. Box files are quicker to use than albums and, if you include alphabetical or subject dividers, retrieval of a particular print is simple. Negatives are best kept in their strips in sleeves made from acid-free materials.

Transparencies are easier to store once they are mounted, and this can be done by the processing laboratory or at home. It may be more convenient to have them mounted by the laboratory, but if you do them at home it is cheaper and you need only mount those images you plan to keep. Some white card mounts can be heat-sealed with a small hand mounter; most plastic mounts can be clipped together. Glass slides are sometimes recommended to protect the image, but the glass can trap dirt. Moreover, if a glass slide breaks it will scratch the film's emulsion, so if you intend to send slides through the post, do not use glass.

Slides should be labelled with a caption and, if you intend to loan them to others, your name, a copyright symbol (©) and the

A montage of prints is interspersed with some of my sons' early artwork. You could use pressed flowers or leaves instead.

date the image was taken. This can either be written on the card mount or, when using plastic mounts, on adhesive labels. The computer has made printing labels a simple task, with software available to ensure that your typing lines up with the labels.

Display sheets are available for slides. They are designed to fit into A4 loose-leaf folders or as hanging files, which, with a metal bar, can be hung in a filing cabinet. Cheaper PVC sheets are made, but archival sheets made from a lightweight polypropylene are said to protect your slides and negatives for up to 800 years, which should be enough for most people's requirements.

A light box – the bigger the better – is an invaluable aid in viewing, sorting and filing your slides. Mine is 12 x 18in (30 x 45cm), which enables me to view a whole hanging sheet of 24 slides, or two A4 sheets of 20 slides side by side. You may want to try building your own using a perspex surface and a daylight-corrected fluorescent lamp. A loupe is a magnifying lens that allows you to view your slides in greater detail. Buy the best one that you can afford as the lenses vary widely in quality, and make sure that it is large enough to view the whole transparency.

Prints can be displayed on simple mounting boards, and using re-positional adhesive (available in spray cans) makes fixing prints an easy task. Window mounts with bevelled edges look more impressive and can be prepared at home with cutting mats and rotary trimmers. Basic clip frames are cheap and easy to find, and ensure that it is your photograph and not the frame that gets attention. The large clip frames designed for displaying posters are ideal if you want to create a photomontage of your pictures. To add to the texture and interest of such a display, you could include pressed flowers and leaves from your garden, or perhaps the colourful seed packets that your plants originated from.

A large number of projectors are available for viewing transparencies; images can be projected onto a screen or shown on a monitor. If you are using your transparencies to illustrate lectures to groups, having your own projector is a distinct advantage as you can then ensure that it is in good working order, has spare bulbs, and that you are familiar with working it. When using someone else's, make sure that you arrive in good time to load your slides and check that you can operate the equipment. Digital projectors are becoming more widely available, and they enable you to prepare a slide presentation directly from your laptop. However, they are still very expensive, and so are unlikely to be within the reach of most horticultural societies.

DIGITAL IMAGES

To store digital images in your computer, set up folders on your hard drive, naming them as overall subject areas. For example, you may have folders named Garden Views, Wildlife, and Plant Portraits. Within these folders you can then create additional folders; within Plant Portraits you may have Trees, Bulbs, Herbaceous Perennials, and so on. When retrieving your pictures, use Photoshop or a similar piece of software that displays small 'thumbnail' images to make selection simple. Remember that high-resolution images take up a lot of memory space, so make sure you have at least 10 gigabytes (GB) of hard-drive space to begin with. To supplement this you can either install another hard disk or transfer your pictures to a removable form of storage, such as a CD or Zip disk. Ordinary floppy disks may be suitable for low-resolution images, but most images will exceed the limited space that they provide. A Zip drive is used in the same way as a floppy disk, but each disk can hold up to 100MB of data. A drawback is that Zip disks require a special, separate drive of their own. Digital images can be transferred to a compact disc for viewing later. CDs are cheap, making them ideal if you want to send your images to friends. It is important to remember that computers can and do crash from time to time, making it wise to have back-ups of all your pictures on CD.

SELLING YOUR WORK

SUBMITTING PHOTOGRAPHS.

IMAGE LIBRARIES.

PHOTOGRAPHIC COMPETITIONS.

Gardening magazines are always on the look out for images of original garden ideas,
such as this grass spiral at Blakenham Woodland Garden, England.
28–80mm zoom lens, Fuji Astia, 1/30sec at f/5.6

Photography can be an expensive hobby. Even after you have bought the gear, there is the cost of films and developing to consider and digital cameras can use batteries rapidly. Once you have had some experience and are beginning to take good pictures, you may want to consider selling some of your images to help cover some of these costs.

SUBMITTING PHOTOGRAPHS

Good images of plants and gardens are always in demand for greetings cards, calendars and books, but the biggest single market open to freelance photographers is magazines. Worldwide there are numerous magazines that require a constant supply of new images. Look through a selection of magazines at your local newsagent and see if your pictures are of a comparable quality. It is a very competitive market, so for your images to sell they must be of top quality and preferably a little out of the ordinary. Different magazines may prefer a particular style of photograph, whether it be traditional garden shots or more artistic images of flowers, so tailor your submissions to an individual magazine.

When making a submission, do not swamp the editor with hundreds of your pictures or they will probably be returned to you without being looked at. Prepare a professional-looking submission of up to two dozen interesting and technically perfect pictures. Send slides not prints, taken with a slow film such as Fujichrome Velvia, which is admired in the industry for its punchy colours. 35mm transparencies are generally acceptable, but some of the big, glossy gardening magazines will only take medium-format images. Make sure that each image is captioned with accurate, up-to-date botanical names; most publishers rely on the Royal Horticultural Society's *RHS Plantfinder* for nomenclature,

When submitting your work to publishers, magazines or picture libraries, make sure that they are presented professionally. The collection of photographs on the right resulted in the commission to write this book.

149

which is updated annually. Also include your name, contact details and copyright symbol, and place the slides in transparent file sheets or black card masks for easy viewing. Enclose a brief covering letter and a list of the pictures submitted, and remember to enclose a pre-stamped self-addressed envelope for the return of your images. Use a padded or stiff-backed envelope to protect your slides in the post, and consider insuring the package in case it is lost or damaged in transit.

Some publishers are beginning to use digital images, but you should not send any pictures by email – nobody wants their email clogged up for hours with unsolicited submissions. Always check first before sending anything electronically, and stick to the format that they suggest (usually as low-resolution JPEGs saved on a Zip disk or CD for submission purposes, with high-resolution TIFF files on CD).

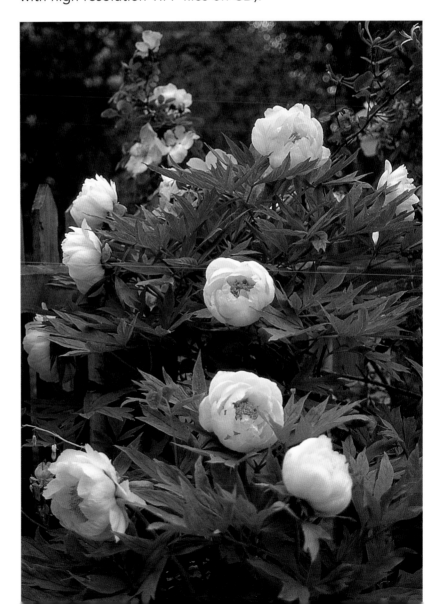

Make sure that any plants are correctly labelled with their up-to-date botanical name. This is *Paeonia* 'High Noon', a tree peony (strictly speaking a shrub) bred by the American A.P. Saunders in 1952. *28–80mm zoom lens, Fuji Astia, tripod, 1/60sec at f/22*

IMAGE LIBRARIES

If you have built up a large stock of images, you may want to consider placing them with a picture library, which will edit your work and sell it to markets worldwide. They will not actually sell the picture as such, but only a license to reproduce that image in specific ways – copyright to the picture will remain with you. Many of the larger picture libraries produce glossy colour catalogues of images that are sent out to their regular customers, and they may have an online image bank. Picture libraries take a commission of up to 50% from all sales, which may sound a lot, but they will reach far more potential customers than you could on your own and they can sell the same image to more than a dozen different buyers. Many libraries will require you to have a legally valid property-release form for all images of recognizable gardens, buildings and/or people in gardens. This ensures that they will only use pictures of gardens with the owner's consent.

Most picture libraries would expect an initial submission of 50 to 100 images, and if accepted on their books they would expect you to build up a stock of several thousand pictures.

This original flint seat is the kind of subject popular with many garden magazines.
28–80mm zoom lens, Fuji Astia, tripod, 1/180sec at f/22

Many libraries now deal with digital images, typically those with file sizes ranging from 40 to 60MB. An up-to-date list of picture libraries is included in *The Writers' and Artists' Handbook* (see Bibliography, page 171) or, alternatively, you will find that a large number of them are on the Internet.

You may also be able to sell original work, either through the Internet if you have your own website, or perhaps by staging an exhibition of work. There are many galleries that specialize in photographic exhibitions but they do tend to have long waiting lists and prefer to deal with known names. Try local venues, a church hall or perhaps the tearoom of a garden that opens to the public regularly. Make an appointment to see the person in charge and show them a selection of your images; it would be usual to offer a commission on any sales made. Arrange publicity by sending a press release to local newspapers and radio stations. Make sure that you exhibit only top-quality prints and that they are attractively mounted and/or framed. A local picture framer may be willing to loan you some frames in return for publicity.

Taken in our orchard, this image of a bee orchid (Ophrys apifera) has featured in a book on orchids.
Sigma 50mm macro lens, Fuji Astia, tripod, 1/250sec at f/11

PHOTOGRAPHIC COMPETITIONS

Even if you are not sure that you feel ready to sell your work, it is always worth entering your pictures in photographic competitions. Many horticultural societies run an annual competition, with prizes awarded to the winners. Even some national societies may not be inundated with entries. The Royal Horticultural Society, which had categories for both professional and amateurs in its 2002 competition, received

some 3,000 entries, but the British Clematis Society's photography competition for 2002 received just 91 photographs from 16 entrants. Standards, however, can be very high. To maximize your chances you must make sure that you have thoroughly read the rules; many otherwise worthy entries are disqualified because competitors have entered prints of the wrong size or submitted a photograph to an inappropriate category. Images must be well composed and focused, and show good use of light.

If slides are requested, ensure that they are labelled as required, and have prints enlarged to the maximum size permitted by the rules. If prints can be mounted, choose a neutral-coloured mounting board. Window mounts with a border of about 2in (5cm) usually look best.

Try to see the winning entries from previous competitions. The RHS publish winning pictures on its website, and the Alpine Garden Society usually publishes the winning photographs (along with a useful critique) in the June issue of its bulletin. The judges will be looking for strict adherence to the rules, technical ability and originality. The Hungarian scientist Albert Szent-Gyorgyi said 'Discovery consists of seeing what everyone else has seen and thinking what no one else has thought.' The true art of photography consists of seeing what everyone else has seen, but picturing it in a way that no one else has thought.

Entering photography competitions run by horticultural societies or the photographic press is a good way of testing the standard of your work.

LEARNING FROM
YOUR MISTAKES

SOME SUGGESTIONS.

LEARNING FROM OTHER SOURCES.

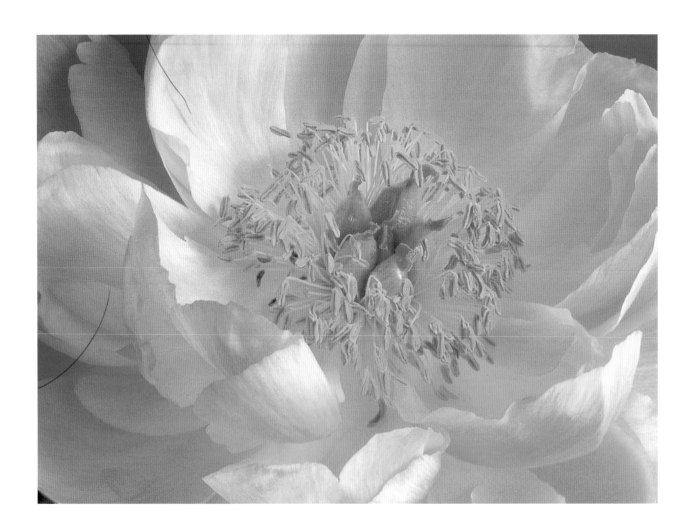

The thin black line towards the top left-hand corner of this image results
from a hair actually within the body of my macro lens, which required an
expensive trip to the repair shop to be removed.

We all make mistakes: the finger across the lens image, shots underexposed to the point of blackness, and blurred shots that could be just about anything. The best way to improve your photography skills is to take lots of pictures, to analyse why the good ones are good and what went wrong with the others, and to use this analysis with your next set of pictures.

SOME SUGGESTIONS

One of the most important tools you can have is a notebook. You may think that you will remember which lens and what exposure you used for a particular shot, but unless you have a really remarkable memory, by the time you have printed your

This is a classic 'finger across the lens' shot. Fortunately, it would be easy to crop the picture to remove the offending finger from the top right of the image.

The hexagonal spots by the flower stem are the result of light causing internal reflections within the lens. I was not using a lens hood, which would probably have prevented them. However, I could always claim that they were intentional, designed to add to the romantic mood of the image.

images these details will be forgotten. A notebook will help you to keep track of which film, filter, aperture and shutter speed you used for any particular shot. If you like computers, you can create a table for these details, but do not aim to record too much data or it will quickly become a chore that you will neglect.

Remember that practice makes perfect (or at least better than average) pictures. Shoot comparison photographs – one with and one without a particular filter, one at slow shutter speed and one fast – so that you can see which is the most effective

The flare in the top left of this image was also caused by neglecting to use a lens hood.

One of the dangers of taking photographs in gardens open to the public is that people will walk by just as you are taking a picture. In this case, cropping the top of the image to remove the figure would not affect the subject itself.

157

While this picture has an attractive soft look, the hot-air balloon in the distance is somewhat obscured. Aligning a neutral-graduated filter with the top half of the picture would darken that half of the image making the balloon more noticeable, and the use of a UV or polarizing filter would have cut the haze.

technique in any given situation. Do not be mean with film – it does not matter if you only have one good picture from a roll of film, you will learn from the others. This is where a digital camera is a real boon, as you can review your images and delete the unsatisfactory ones without the cost of developing.

Always try to keep your camera in a place that is easily accessible. That way, you will never miss a shot simply because your camera was not to hand. If it is carefully packed

This is the closest I have ever got to a picture of a great spotted woodpecker on our bird feeder. I suspect that every wildlife photographer has a large collection of blurred images showing the 'ones that got away'. Patience and persistence are the answers here.

away in a cupboard you may miss some of those wonderfully atmospheric – but all too fleeting – moments of perfect, evocative lighting.

A common mistake is not paying sufficient attention to the background. If you cannot avoid a distracting background, set the maximum aperture possible to throw it out of focus, or zoom in close on the main subject. You can always crop your pictures later, or digitally remove a tree growing from

Plant labels carried to excess can be a garden photographer's nightmare. In your own garden you can move them temporarily; in someone else's garden you must put up with them or choose a different subject.

someone's head, but it is good practice to avoid this kind of mistake in the first place. Concentrate on strong composition, and keep things simple for maximum impact. Get in close for striking abstract pictures, and use a tripod, especially for macro work.

This was meant to be a shot of winter gardening – in front of the fire with the new season's catalogues – but the strong colour cast from tungsten lighting and the fire rather overwhelms everything else. Use a tungsten-balanced film or a blue filter to give more natural-looking colour in these circumstances.

Stray pampas grass stems cutting across the front of the picture are very distracting. Asking someone to hold such distractions out of the frame will help, as long as you are sure your assistant's hand will not be seen either.

Do not blame your camera for every unsatisfactory shot or think that investing in the latest technology will solve all your problems – stunning images can be created even with a pinhole camera. Simple, cheap items, such as a beanbag to hold your camera steady and a sheet of white card to act as a reflector, can make a great difference to a photograph.

The birch stem to the left of this image is distracting. Re-framing the image to position the sculpture to the left would have improved the composition.

This view shows vignetting caused by using a filter holder with a wide-angle lens.

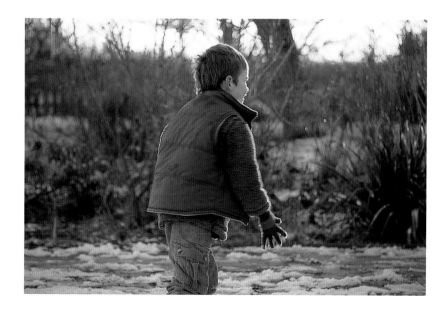

Using a slow shutter speed to give a slightly blurred 'action' shot of a snowball fight would have made a more interesting picture.

LEARNING FROM OTHER SOURCES

You can learn from other people, too, especially if you get into the habit of looking at photographs with a critical eye. We are surrounded by images in newspapers, magazines and books, and on greetings cards and posters. When you see an image that pleases you, try to work out why it is successful. Is it the colours that attract you, or a repeated pattern? Does the lighting reveal interesting textures, or are the subjects composed in an unusual arrangement? The principles behind creating a striking image are similar whatever the subject, so do not confine yourself to looking at garden photography. Look at the work of the best landscape, fashion, reportage and wildlife photographers; study Erasmus Schroeter's use of light or Ansel Adam's composition techniques.

The boys picking the last of the season's apples are totally obscured by a jumble of branches. Getting in closer and using a very shallow depth of field to isolate the boys from the leaves may have made a worthwhile picture.

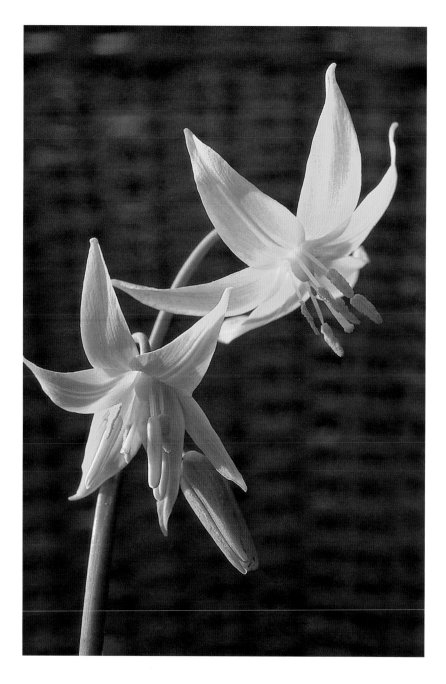

I picked a stem of *Erythronium tuolumnense* so that I could set up a still-life photograph on a very windy day. The lighting is lovely, but the choice of background unappealing.

Take a look at some current photography magazines. Many include useful features on technique and some have 'problem pages' to which readers can send in their photographs for comments and advice. There are also books available on all aspects of photography. You could even suggest that your local horticultural society invite along a garden photographer to give a lecture. If you are really keen there are various courses, workshops or evening classes that you can attend. Some photography courses are arranged in exotic locations so you can combine a training session with a holiday.

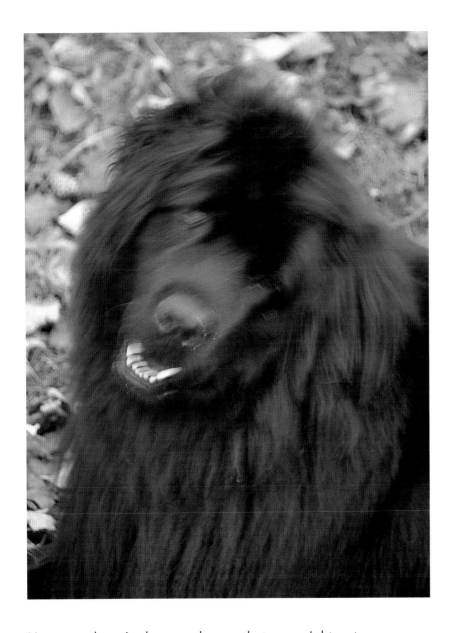

Advice such as 'never work with animals or children' could easily apply to photographers; neither group of subjects can be relied on to stay still.

However, there is always a danger that you might get so wrapped up with equipment and techniques that you forget why you are taking pictures in the first place. If there comes a time when you cannot admire a sunset without thinking 'would I need a neutral-graduated filter for that?' perhaps you need to put down your camera for a while and remember that there will always be some things that the camera cannot capture. Consider the essence of what your garden means to you and then think about ways of condensing this into your images. Every garden has its own individual character and atmosphere. An artist would use canvas, brush and paint to record his personal interpretation of that garden; you should try to do the same with your use of composition, light and colour.

This picture of the boys was spoilt because I did not follow my own advice: always carry a reflector with you. A simple white card reflector would have bounced enough light into their faces to make a good picture.

Browse around the news-stands and you will find a large number of photography magazines. Some have really useful features that can give you a lot of new ideas.

Look at a variety of photography
books as well as gardening books
for inspiration and practical help.

Remember to concentrate on what attracted you to your chosen subject
(here the velvety texture of the rose petals) and eliminate all extraneous detail.

GLOSSARY

APERTURE
The opening in the camera lens that controls the amount of light that passes through to create an image.

BRACKETING
A technique by which exposures are made at settings that are increased and decreased around the camera's suggested reading to ensure a perfectly exposed shot.

CCD
Charge-coupled device. An electronic light sensor that turns a scene into a digital image.

CD-ROM
A compact disc for storage of digital images, text or sound, which is read by a CD-ROM drive attached to or built into a computer.

DEPTH OF FIELD
The area within an image that is in sharp focus. Decreasing the lens aperture increases the depth of field.

DEPTH-OF-FIELD PREVIEW
A feature of some cameras that allows you to check the depth of field before taking a picture.

DIGITAL IMAGE
An image recorded as electrical data and made up of pixels.

DISK
A magnetically or optically etched medium on which data is stored.

EXPOSURE
The amount of light that falls on the film or CCD. It is controlled by a combination of lens aperture and shutter speed.

EXPOSURE COMPENSATION
A method of overriding an automatic exposure mode to lighten or darken an image.

FILL-IN FLASH
A low-powered burst of flash used to reveal detail in a shaded subject area.

FILTER
A glass or optical resin disc or sheet that fits in front of the lens modifying the light that passes through.

FOCAL LENGTH
The distance between the centre of the lens and the point at which light rays are focused. It determines a lens's angle of view and its ability to magnify a subject.

FOCUS
Adjustment of the lens to produce a clearly defined image.

HOT SHOE
A metal plate on the camera that allows you to attach a flash gun.

ISO
International Organization of Standardization. A number used to indicate a film's sensitivity to light. Higher ISO ratings indicate a more sensitive film.

JPEG

Developed by the Joint Photographic Experts Group. A popular form of compression used for digital images to reduce the file size.

MACRO

Technically means life-size reproduction, so that the image on a negative is the same size as the subject in real life. The term is often used to indicate close-up pictures in general.

MANUAL EXPOSURE MODE

A mode in which the photographer sets the camera's aperture and shutter speed.

MEMORY CARD

A removable card used in digital cameras to store pictures. It could be thought of as the digital equivalent of film, but can be wiped clean and reused.

PARALLAX ERROR

The difference between what your eye sees through the viewfinder and the actual image obtained by the lens.

PIXEL

Picture element. A tiny square of data that contains the information that makes up a digital image. The CCD in a 4 megapixel digital camera has 4 million individual sensors, each representing one pixel.

SCANNER

Device to convert prints, artwork or film into digital form, enabling them to be manipulated on a computer using image-editing software.

SHUTTER RELEASE

The button used to take a picture.

SLR

Single-Lens Reflex. A camera that uses a reflex mirror to allow the user to focus and compose a picture by looking through the lens.

STOP

The difference between two aperture or shutter-speed settings.

TIFF

Tagged Image File Format. A high-quality compression format for digital images.

TTL

Through The Lens. Usually refers to light metering by an exposure meter that is built into the camera, which measures the light (reflected from a subject) passing through the lens.

BIBLIOGRAPHY

Gardens of England and Wales Open for Charity
Marchioness of Salisbury (Introduction)
(The National Gardens Scheme
Charitable Trust, 2003)

New Introductory Photography Course
by John Hedgecoe
(Mitchell Beazley, 1996)

Photographing Plants and Flowers
by Paul Harcourt Davies
(Collins and Brown, 2002)

Photographing Plants and Gardens
by Clive Nichols
(David and Charles, 1998)

RHS Plant Finder: 2000/2001
by Chris Pellant
(Dorling Kindersley, 2000)

The Royal Society for the Protection of Birds Guide to Bird and Nature Photography
by Laurie Campbell
(David and Charles, 1990)

The Writers' and Artists' Yearbook: 2003
(A and C Black, 2002)

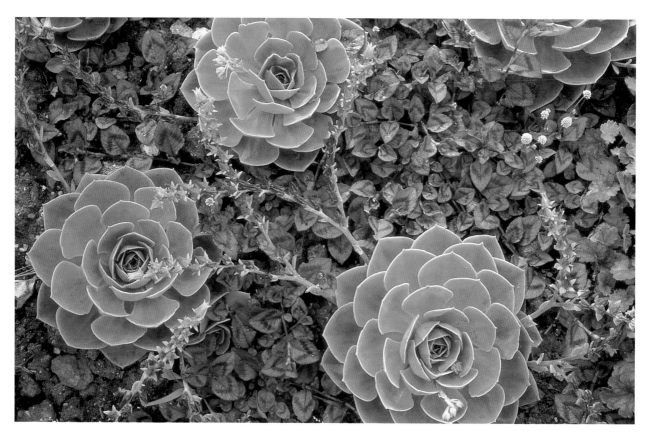

USEFUL ADDRESSES

VISITING GARDENS

UNITED KINGDOM
National Gardens Scheme
Hatchlands Park
East Clandon
Guildford, Surrey GU4 7RT
Website: www.ngs.org.uk

Scotland's Gardens Scheme
22 Rutland Square
Edinburgh EH1 2BB

AUSTRALIA
Australia's Open Garden Scheme
Westport
New Gisborne
Victoria 3438
Website: www.opengarden.abc.net.au

BELGIUM
Jardins Ouverts
Chaussee de Vleurgat 108
1000 Brussels

JAPAN
Garden Open Story (NGS Japan)
4-19-21 Yutaka-cho Shinagawa-ku
Tokyo 142-0042
Website: www.ngs.jp.org

UNITED STATES
The Garden Conservancy
PO Box 219
Cold Spring
New York 10516
Website: www.gardenconservancy.org

HORTICULTURAL SOCIETIES

UNITED KINGDOM
The Alpine Garden Society
AGS Centre
Avon Bank
Pershore
Worcestershire WR10 3JP
Website: www.alpinegardensociety.org

The British Clematis Society
Valantine Cottage, Newnham Road
Hook
Hampshire RG27 9AE
Website: www.britishclematis.org.uk

The Cottage Garden Society
'Brandon'
Ravenshall
Betley
Cheshire CW3 9BH
Website: www.thecgs.org.uk

The Hardy Plant Society
Little Orchard
Great Comberton
Nr Pershore
Worcestershire WR10 3DP
Website: www.hardy-plant.org.uk

The Royal Horticultural Society
80 Vincent Square
London SW1P 2PE
Website: www.rhs.org.uk

NORTH AMERICA
American Horticultural Society
7931 East Boulevard Drive
Alexandria
VA 22308
Website: www.ahs.org

American Orchid Society
16700 AOS Lane
Delray Beach
FL 33446-4351
Website: www.orchidweb.org

Canadian Rose Society
10 Fairfax Crescent
Toronto
Ontario M1L 1Z8
Website: www.mirror.org/groups/crs

ABOUT THE AUTHOR

© Jonathan Harland

Formerly a dietitian specializing in diabetes, Gail Harland was bitten by the gardening bug around the time she had her first son. Having taken first the Royal Horticultural Society's Certificate in Horticulture and then the Diploma in Horticulture, she now writes articles and takes photographs for the horticultural press. She is involved in a number of horticultural societies and edits the newsletter for the Peony Society.

Gail lives in Suffolk, in the east of England, with her husband, two children and an assortment of animals. She has an acre of rather wild-looking garden, which is nevertheless full of fascinating plants and the source of many of her photographs.

INDEX

A

accessories 12, 40–50
acid-free paper 143
Adam, Ansel 163
adapter brackets 106
Advanced Photo System (APS) cameras 17,
 19–20, 23, 145
aide-memoires 6
albums 145–7
Alpine Garden Society 153
altitude 81
animals 103–5
apertures 17, 20, 26, 28
 accessories 41–2, 46
 composition 65–6
 exposure 69–71
 lighting 78
 meters 31–2
 subjects 96, 103, 119, 121
apochromatic lenses 28
architecture 90–2, 125–7
archives 142–7
artificial lighting 81–3
autofocus 19, 20, 31, 46, 105
automatic flash 32–3
automatic-metering systems 20
averaging 31

B

back lighting 31, 79–80, 83
background 83, 119, 159
bags 49
ball-and-socket head 42
batteries 132
beanbags 43, 111, 161
bees 109, 112, 120
before-and-after pictures 6
birds 109–11, 126

black-and-white film 38, 45, 48, 77, 92
blurring 70, 78, 101, 111, 119, 155
botanical illustrations 10
bracketing 72–3, 125, 132
breeders 7
bright sunshine 130–4
British Clematis Society 153
butterflies 109, 111–12, 126

C

cable release 49, 106
camera obscura 17
camera shake 27–8, 42, 49, 70, 101–2
cameras 12–13, 17–18, 49
Canon 13, 21, 69
catadioptric lenses 28
cataloguing 17, 145
cats 104–5
centre-weighted metering 31
changing seasons 128–35
charge-coupled device (CCD) 22
charity organizations 137
children 99–101
circular polarizers 46
classes 164
Classic (C) format 19
close-up shots 27, 33, 41–2, 49, 76, 82,
 121–2
cloud 76, 117, 134
colour 29, 46, 60–4, 71
 filters 47–8, 80–1
 print 35–7
 shifts 73
 temperature 80
combinations of plants 116–26
compact cameras 18–19, 20, 44–5
compensation settings 71
competitions 152–3

composition 52–67, 89, 95–6, 120–1,
 160, 163
contrast 31, 38, 44, 46, 48
 composition 63
 exposure 72
 lighting 76, 79
 subjects 101, 133–4
converging lines 60
copyright 145, 150–1
Cottage Garden Society 138
country gardens 87
critical appraisal 5

D
dawn 80
depth of field 26, 28, 46
 composition 65–7
 exposure 69–70
 lighting 76, 80
 subjects 96, 121
details 10, 126–7
diagnostic details 10
diagonals 60, 62
diffusers 43–4
digital cameras 17, 20, 22–3, 26
 accessories 44–5
 files 143
 images 147, 150, 152, 158
 projection 35
dioptre 41
direction of light 78–80
display 142–7
domestic animals 103–5
dragonflies 112
dusk 80, 90

E
elements 25–6, 41, 92
email 150
equipment 110, 117, 132
 mistakes 165

selection 15–50
 use 51–84
evaluative metering 31
evening 77
exhibitions 152
exposure 33, 35, 41–2
 equipment 68–73, 76–9, 82
 meters 31
 subjects 111, 113, 121, 125, 132
extension tubes 27, 31, 41, 122

F
fast film 35–7, 46
field of view 27
fill-in flash 76, 80–3
film 17, 19, 23, 34–9
filters 41, 44–5, 77, 81
 seasons 133–4
 subjects 113, 127
flare 45, 80
flash 30, 32–3, 44, 76, 79, 81–3, 101
flatbed scanners 23
flicker 81
flower shows 38
fluorescent lighting 81
focal length 26–8, 56, 65, 102, 110, 112
focal points 96, 129
focus 27, 41, 65–7
fog 130–4
footprints 132
form 125–6
formats 19, 21–2
frames 145–7, 152
framing 56–60, 95–6
front gardens 89–90
frontal lighting 79
Fujichrome Velvia 37, 149

G
garden settings 87–92
glare 46, 113, 134

graduated filters 46–7, 134
grain 19, 35, 37
grey card 32
guide numbers 33

H
hand-held cameras 35, 69, 102, 138
hand-held meters 31–2, 71, 77, 132
hard landscaping 127
haze 45–6, 76–7, 134
hides 109, 111
High-Definition Tele-Vision (HDTV) format 19
holidays 138, 164
home-printing options 22
horizontal composition 57, 59, 95, 120
horticultural societies 7, 138, 147, 152, 164
hot-shoe fitting 32, 92

I
identification 6, 10
image libraries 151–2
image-stabilization lenses 28
incident light 31, 77, 132
individual plants 116–26, 129
insects 111–12
International Standards Organization (ISO)
 35, 37, 73
Internet 17, 22, 138, 152

K
Kodak 37, 81

L
labels 120, 139
ladybirds 112
landscapes 22, 37, 59, 77, 81
large-format cameras 22, 42
law 138
lectures 7, 164
lens hoods 29, 80, 82
lens tissues 132

lenses 24–9
life-size reproductions 28
light 74–84, 90, 111
 artificial 81–3
 boxes 83, 146
 colour 80–1
 direction 78–80
 intensity 76–8
 measurement 71–2
 meters 30–2
 mistakes 163
 subjects 117, 132
linear polarizers 46
long-focus lenses 27
loupes 146
low light 73

M
macro lenses 27–8, 41, 112, 122, 160
magazines 17, 35, 75, 99, 149, 164
mammals 109–11
manual cameras 20, 46
manual flash 32
manufacturers 21
matrix metering 31
medium-format cameras 21–2, 27, 42
metering 71–2, 78, 132
Minolta 20, 21
mirror lenses 28
mist 132
mistakes 154–67
monopods 43
moonlight 78
morning 77
moving subjects 20

N
National Gardens Scheme 137
negatives 23, 35, 145
neutral-density filters 44–7
Niepce, Joseph N. 35

Nikon 21
notebooks 155–6

O
Olympus 21
other people's gardens 136–9
overexposure 69–71, 73, 83, 125, 132–3

P
pan-and-tilt head 42
panning 101
panoramas 59, 93–7
Panoramic (P) format 19
parallax 19, 20
partial metering 31
partnerships 114–27
pattern 60–4
Pentax 21
people 98–107, 135
perspective 27, 53–5, 92
pets 98, 103–7
photographer's eye 12
photographic paper 22
photomontages 145–7
picture libraries 151–2
pixels 22, 23
plant portraits 114–27
polarizers 44–6, 77, 81, 113, 127, 133
ponds 113
pressed specimens 7, 10
preview buttons 46, 67, 80, 121
printing options 22
project work 134–5
projection 35, 147

R
rain 117, 130–4
reciprocity 70, 73, 78
record-keeping 6–7, 156
reflected light 132

reflectors 43–4, 76, 79, 82–3, 161
reflex lenses 28
remote release 48–9, 106, 121
restoration project 134–5
reversal films 35
reversing rings 42
right-angle viewing attachments 42
rim lighting 79
ring flash 33, 82
Royal Horticultural Society (RHS) 138, 149, 152–3

S
scanners 23
Schroeter, Erasmus 163
Schulze, Johann 35
seasons 128–35
second-hand equipment 18
self-timers 48–9, 105–7, 121
selling 148–53
sequences 129
shadows 28–9, 32–3, 44, 72
 lighting 76–7, 79–80
 seasons 133
 subjects 117
shape 60–4
shift lenses 92
shutter speed 17, 20, 31
 accessories 42, 46, 48
 exposure 69–73
 lighting 77–8, 81–2
 subjects 101–2, 111, 121
side lighting 79
signatures 126
silhouette effect 80
single-lens reflex (SLR) cameras 13, 17, 20–1, 23, 25, 44–5
skylight filters 44, 45
slave units 33
slides 23, 35, 143, 145–7, 149–50, 153

slow film 35, 42, 69, 149
snow 130–4
soft box attachments 82
soft focus 96
software 143, 146, 147
specialist film 38
spot metering 31
spring 5, 129
squirrels 111
standard lenses 27, 41–2, 102, 122
still life 27
stops 69
storage 143–5
stripes 60
studio work 22, 33, 81–3
subject selection 85–140
submitting photographs 149–50
summer 5, 129
sun 76–8, 80–1, 117, 130–4
supports 27, 42–3, 78

T
telephoto lenses 26–8, 41
 composition 55, 65
 lighting 78
 subjects 99, 102, 110, 122, 124
texture 79, 83, 146
three-dimensional forms 79, 80, 82
through-the-lens (TTL) metering 31, 71
tone 71, 72
topiary 126
transparencies 21, 23, 35
 archives 143, 145, 147
 selling 149
transparency film 35–7, 48, 71, 73
trespassing 138
trials 17
tripods 27–8, 35, 42–3, 49
 exposure 70, 76
 lighting 78

mistakes 160
 subjects 92, 101–2, 105, 121, 137
 wildlife 111
tungsten lighting 81
tungsten-balanced film 38
twilight 77

U
ultraviolet (UV) filters 44–5, 77, 81, 134
underexposure 69–71, 73, 125, 155
urban gardens 87–90

V
vertical composition 57, 95, 120
vibration 48, 121
vibration-reduction (VR) lenses 28
viewfinders 19, 31, 53, 72, 105, 117
viewpoints 53–5, 80, 120
views 93–7
vignetting 29, 45
virtual tours 138
visiting gardens 137–9
vistas 93–7

W
warm-up filters 44–5, 46, 48
warning systems 72
white gardens 125
wide-angle lenses 26–7, 29, 32
 accessories 42, 45
 composition 55–6, 60
 subjects 92, 96
wildlife 108–13, 126
windows 111, 132
winter 5, 129, 130

Z
Z-rings 42
zoom lenses 19, 26, 28, 41, 45, 99, 124

TITLES AVAILABLE FROM
GMC Publications
BOOKS

WOODCARVING

Beginning Woodcarving — *GMC Publications*
Carving Architectural Detail in Wood:
The Classical Tradition — *Frederick Wilbur*
Carving Birds & Beasts — *GMC Publications*
Carving the Human Figure: Studies in Wood and Stone
— *Dick Onians*
Carving Nature: Wildlife Studies in Wood
— *Frank Fox-Wilson*
Carving on Turning — *Chris Pye*
Celtic Carved Lovespoons: 30 Patterns
— *Sharon Littley & Clive Griffin*
Decorative Woodcarving (New Edition) — *Jeremy Williams*
Elements of Woodcarving — *Chris Pye*
Essential Woodcarving Techniques — *Dick Onians*
Figure Carving in Wood: Human and Animal Forms
— *Sara Wilkinson*
Lettercarving in Wood: A Practical Course — *Chris Pye*
Relief Carving in Wood: A Practical Introduction
— *Chris Pye*
Woodcarving for Beginners — *GMC Publications*
Woodcarving Made Easy — *Cynthia Rogers*
Woodcarving Tools, Materials & Equipment
(New Edition in 2 vols.) — *Chris Pye*

WOODTURNING

Bowl Turning Techniques Masterclass — *Tony Boase*
Chris Child's Projects for Woodturners — *Chris Child*
Contemporary Turned Wood: New Perspectives in
a Rich Tradition — *Ray Leier, Jan Peters & Kevin Wallace*
Decorating Turned Wood: The Maker's Eye
— *Liz & Michael O'Donnell*
Green Woodwork — *Mike Abbott*
Intermediate Woodturning Projects — *GMC Publications*
Keith Rowley's Woodturning Projects — *Keith Rowley*
Making Screw Threads in Wood — *Fred Holder*

Segmented Turning: A Complete Guide — *Ron Hampton*
Turned Boxes: 50 Designs — *Chris Stott*
Turning Green Wood — *Michael O'Donnell*
Turning Pens and Pencils
— *Kip Christensen & Rex Burningham*
Woodturning: Forms and Materials — *John Hunnex*
Woodturning: A Foundation Course (New Edition)
— *Keith Rowley*
Woodturning: A Fresh Approach — *Robert Chapman*
Woodturning: An Individual Approach — *Dave Regester*
Woodturning: A Source Book of Shapes — *John Hunnex*
Woodturning Masterclass — *Tony Boase*
Woodturning Techniques — *GMC Publications*

WOODWORKING

Beginning Picture Marquetry — *Lawrence Threadgold*
Celtic Carved Lovespoons: 30 Patterns
— *Sharon Littley & Clive Griffin*
Celtic Woodcraft — *Glenda Bennett*
Complete Woodfinishing (Revised Edition) — *Ian Hosker*
David Charlesworth's Furniture-Making Techniques
— *David Charlesworth*
David Charlesworth's Furniture-Making Techniques –
Volume 2 — *David Charlesworth*
Furniture-Making Projects for the Wood Craftsman
— *GMC Publications*
Furniture-Making Techniques for the Wood Craftsman
— *GMC Publications*
Furniture Projects with the Router — *Kevin Ley*
Furniture Restoration (Practical Crafts) — *Kevin Jan Bonner*
Furniture Restoration: A Professional at Work — *John Lloyd*
Furniture Restoration and Repair for Beginners
— *Kevin Jan Bonner*
Furniture Restoration Workshop — *Kevin Jan Bonner*
Green Woodwork — *Mike Abbott*
Intarsia: 30 Patterns for the Scrollsaw — *John Everett*

Kevin Ley's Furniture Projects — *Kevin Ley*

Making Chairs and Tables – Volume 2 — *GMC Publications*

Making Classic English Furniture — *Paul Richardson*

Making Heirloom Boxes — *Peter Lloyd*

Making Screw Threads in Wood — *Fred Holder*

Making Woodwork Aids and Devices — *Robert Wearing*

Mastering the Router — *Ron Fox*

Pine Furniture Projects for the Home — *Dave Mackenzie*

Router Magic: Jigs, Fixtures and Tricks to
 Unleash your Router's Full Potential — *Bill Hylton*

Router Projects for the Home — *GMC Publications*

Router Tips & Techniques — *Robert Wearing*

Routing: A Workshop Handbook — *Anthony Bailey*

Routing for Beginners — *Anthony Bailey*

Sharpening: The Complete Guide — *Jim Kingshott*

Space-Saving Furniture Projects — *Dave Mackenzie*

Stickmaking: A Complete Course
 Andrew Jones & Clive George

Stickmaking Handbook — *Andrew Jones & Clive George*

Storage Projects for the Router — *GMC Publications*

Veneering: A Complete Course — *Ian Hosker*

Veneering Handbook — *Ian Hosker*

Woodworking Techniques and Projects — *Anthony Bailey*

Woodworking with the Router: Professional Router
 Techniques any Woodworker can Use
 Bill Hylton & Fred Matlack

UPHOLSTERY

Upholstery: A Complete Course (Revised Edition)
 David James

Upholstery Restoration — *David James*

Upholstery Techniques & Projects — *David James*

Upholstery Tips and Hints — *David James*

TOYMAKING

Scrollsaw Toy Projects — *Ivor Carlyle*

Scrollsaw Toys for All Ages — *Ivor Carlyle*

DOLLS' HOUSES AND MINIATURES

1/12 Scale Character Figures for the Dolls' House
 James Carrington

Americana in 1/12 Scale: 50 Authentic Projects
 Joanne Ogreenc & Mary Lou Santovec

The Authentic Georgian Dolls' House — *Brian Long*

A Beginners' Guide to the Dolls' House Hobby
 Jean Nisbett

Celtic, Medieval and Tudor Wall Hangings
 in 1/12 Scale Needlepoint — *Sandra Whitehead*

Creating Decorative Fabrics: Projects in 1/12 Scale
 Janet Storey

Dolls' House Accessories, Fixtures and Fittings
 Andrea Barham

Dolls' House Furniture: Easy-to-Make Projects
 in 1/12 Scale — *Freida Gray*

Dolls' House Makeovers — *Jean Nisbett*

Dolls' House Window Treatments — *Eve Harwood*

Edwardian-Style Hand-Knitted Fashion
 for 1/12 Scale Dolls — *Yvonne Wakefield*

How to Make Your Dolls' House Special:
 Fresh Ideas for Decorating — *Beryl Armstrong*

Making 1/12 Scale Wicker Furniture for
 the Dolls' House — *Sheila Smith*

Making Miniature Chinese Rugs and Carpets
 Carol Phillipson

Making Miniature Food and Market Stalls — *Angie Scarr*

Making Miniature Gardens — *Freida Gray*

Making Miniature Oriental Rugs & Carpets
 Meik & Ian McNaughton

Making Miniatures: Projects for the
 1/12 Scale Dolls' House — *Christiane Berridge*

Making Period Dolls' House Accessories — *Andrea Barham*

Making Tudor Dolls' Houses — *Derek Rowbottom*

Making Upholstered Furniture in 1/12 Scale — *Janet Storey*

Making Victorian Dolls' House Furniture — *Patricia King*

Medieval and Tudor Needlecraft: Knights
 and Ladies in 1/12 Scale — *Sandra Whitehead*

Miniature Bobbin Lace — *Roz Snowden*

Miniature Crochet: Projects in 1/12 Scale — *Roz Walters*

Miniature Embroidery for the Georgian Dolls' House
 Pamela Warner

Miniature Embroidery for the Tudor and
　Stuart Dolls' House　　　　　　　*Pamela Warner*
Miniature Embroidery for the 20th-Century
　Dolls' House　　　　　　　*Pamela Warner*

Miniature Embroidery for the Victorian
　Dolls' House　　　　　　　*Pamela Warner*
Miniature Needlepoint Carpets　　*Janet Granger*
More Miniature Oriental Rugs & Carpets
　　　　　　　Meik & Ian McNaughton
Needlepoint 1/12 Scale: Design Collections
　for the Dolls' House　　　　　　*Felicity Price*
New Ideas for Miniature Bobbin Lace　*Roz Snowden*
Patchwork Quilts for the Dolls' House:
　20 Projects in 1/12 Scale　　　*Sarah Williams*
Simple Country Furniture Projects
　in 1/12 Scale　　　　　　*Alison J. White*

CRAFTS

Bargello: A Fresh Approach to Florentine Embroidery
　　　　　　　Brenda Day
Beginning Picture Marquetry　*Lawrence Threadgold*
Blackwork: A New Approach　　　*Brenda Day*
Celtic Cross Stitch Designs　　*Carol Phillipson*
Celtic Knotwork Designs　　　*Sheila Sturrock*
Celtic Knotwork Handbook　　　*Sheila Sturrock*
Celtic Spirals and Other Designs　*Sheila Sturrock*
Celtic Spirals Handbook　　　*Sheila Sturrock*
Complete Pyrography　　　　*Stephen Poole*
Creating Made-to-Measure Knitwear: A Revolutionary
　Approach to Knitwear Design　　*Sylvia Wynn*
Creative Backstitch　　　　　*Helen Hall*
Creative Log-Cabin Patchwork　*Pauline Brown*
Creative Machine Knitting　　*GMC Publications*
The Creative Quilter: Techniques and Projects
　　　　　　　Pauline Brown
Cross-Stitch Designs from China　*Carol Phillipson*
Cross-Stitch Floral Designs　*Joanne Sanderson*
Decoration on Fabric: A Sourcebook of Ideas
　　　　　　　Pauline Brown
Decorative Beaded Purses　　　*Enid Taylor*
Designing and Making Cards　*Glennis Gilruth*
Designs for Pyrography and Other Crafts　*Norma Gregory*

Dried Flowers: A Complete Guide　*Lindy Bird*
Exotic Textiles in Needlepoint　*Stella Knight*
Glass Engraving Pattern Book　*John Everett*
Glass Painting　　　　　　*Emma Sedman*
Handcrafted Rugs　　　　　*Sandra Hardy*
Hobby Ceramics: Techniques and Projects
　for Beginners　　　　　*Patricia A. Waller*
How to Arrange Flowers: A Japanese Approach to
　English Design　　　　　*Taeko Marvelly*
How to Make First-Class Cards　*Debbie Brown*
An Introduction to Crewel Embroidery　*Mave Glenny*
Machine-Knitted Babywear　　*Christine Eames*
Making Decorative Screens　　*Amanda Howes*
Making Fabergé-Style Eggs　　*Denise Hopper*
Making Fairies and Fantastical Creatures　*Julie Sharp*
Making Hand-Sewn Boxes: Techniques and Projects
　　　　　　　Jackie Woolsey
Making Mini Cards, Gift Tags & Invitations
　　　　　　　Glennis Gilruth
Native American Bead Weaving　*Lynne Garner*
New Ideas for Crochet: Stylish Projects for the Home
　　　　　　　Darsha Capaldi
Papercraft Projects for Special Occasions　*Sine Chesterman*
Papermaking and Bookbinding: Coastal Inspirations
　　　　　　　Joanne Kaar
Patchwork for Beginners　　　*Pauline Brown*
Pyrography Designs　　　　　*Norma Gregory*
Rose Windows for Quilters　　*Angela Besley*
Silk Painting for Beginners　　　*Jill Clay*
Sponge Painting　　　　　　*Ann Rooney*
Stained Glass: Techniques and Projects　*Mary Shanahan*
Step-by-Step Pyrography Projects for the
　Solid Point Machine　　　　*Norma Gregory*
Stitched Cards and Gift Tags　*Carol Phillipson*
Tassel Making for Beginners　　*Enid Taylor*
Tatting Collage　　　　　　*Lindsay Rogers*
Tatting Patterns　　　　　　*Lyn Morton*
Temari: A Traditional Japanese Embroidery Technique
　　　　　　　Margaret Ludlow
Three-Dimensional Découpage: Innovative Projects
　for Beginners　　　　　　*Hilda Stokes*
Trompe l'Oeil: Techniques and Projects　*Jan Lee Johnson*
Tudor Treasures to Embroider　*Pamela Warner*
Wax Art　　　　　　　　*Hazel Marsh*

GARDENING

Alpine Gardening *Chris & Valerie Wheeler*

Auriculas for Everyone: How to Grow and
 Show Perfect Plants *Mary Robinson*
Beginners' Guide to Herb Gardening *Yvonne Cuthbertson*
Beginners' Guide to Water Gardening *Graham Clarke*
Big Leaves for Exotic Effect *Stephen Griffith*
The Birdwatcher's Garden *Hazel & Pamela Johnson*
Companions to Clematis: Growing Clematis
 with Other Plants *Marigold Badcock*
Creating Contrast with Dark Plants *Freya Martin*
Creating Small Habitats for Wildlife in your Garden
 Josie Briggs
Exotics are Easy *GMC Publications*
Gardening with Hebes *Chris & Valerie Wheeler*
Gardening with Shrubs *Eric Sawford*
Gardening with Wild Plants *Julian Slatcher*
Growing Cacti and Other Succulents in the
 Conservatory and Indoors *Shirley-Anne Bell*
Growing Cacti and Other Succulents in the Garden
 Shirley-Anne Bell
Growing Successful Orchids in the Greenhouse
 and Conservatory *Mark Isaac-Williams*
Hardy Palms and Palm-Like Plants *Martyn Graham*
Hardy Perennials: A Beginner's Guide *Eric Sawford*
Hedges: Creating Screens and Edges *Averil Bedrich*
How to Attract Butterflies to your Garden
 John & Maureen Tampion
Marginal Plants *Bernard Sleeman*
Orchids are Easy: A Beginner's Guide to their
 Care and Cultivation *Tom Gilland*
Plant Alert: A Garden Guide for Parents *Catherine Collins*
Planting Plans for Your Garden *Jenny Shukman*
Sink and Container Gardening Using Dwarf
 Hardy Plants *Chris & Valerie Wheeler*
The Successful Conservatory and Growing Exotic Plants
 Joan Phelan
Success with Cuttings *Chris & Valerie Wheeler*
Success with Seeds *Chris & Valerie Wheeler*
Tropical Garden Style with Hardy Plants *Alan Hemsley*
Water Garden Projects: From Groundwork to Planting
 Roger Sweetinburgh

PHOTOGRAPHY

Close-Up on Insects *Robert Thompson*
Digital Enhancement for Landscape Photographers
 Arjan Hoogendam & Herb Parkin
Double Vision *Chris Weston & Nigel Hicks*
An Essential Guide to Bird Photography *Steve Young*
Field Guide to Bird Photography *Steve Young*
Field Guide to Landscape Photography *Peter Watson*
How to Photograph Pets *Nick Ridley*
In my Mind's Eye: Seeing in Black and White
 Charlie Waite
Life in the Wild: A Photographer's Year *Andy Rouse*
Light in the Landscape: A Photographer's Year
 Peter Watson
Outdoor Photography Portfolio *GMC Publications*
Photographers on Location with Charlie Waite
 Charlie Waite
Photographing Fungi in the Field *George McCarthy*
Photography for the Naturalist *Mark Lucock*
Photojournalism: An Essential Guide *David Herrod*
Professional Landscape and Environmental Photography:
 From 35mm to Large Format *Mark Lucock*
Rangefinder *Roger Hicks & Frances Schultz*
Underwater Photography *Paul Kay*
Viewpoints from *Outdoor Photography* *GMC Publications*
Where and How to Photograph Wildlife *Peter Evans*
Wildlife Photography Workshop *Steve & Ann Toon*

ART TECHNIQUES

Oil Paintings from your Garden: A Guide for Beginners
 Rachel Shirley

VIDEOS

Drop-in and Pinstuffed Seats *David James*
Stuffover Upholstery *David James*
Elliptical Turning *David Springett*
Woodturning Wizardry *David Springett*
Turning Between Centres: The Basics *Dennis White*
Turning Bowls *Dennis White*
Boxes, Goblets and Screw Threads *Dennis White*
Novelties and Projects *Dennis White*

Classic Profiles	*Dennis White*
Twists and Advanced Turning	*Dennis White*
Sharpening the Professional Way	*Jim Kingshott*
Sharpening Turning & Carving Tools	*Jim Kingshott*
Bowl Turning	*John Jordan*
Hollow Turning	*John Jordan*
Woodturning: A Foundation Course	*Keith Rowley*
Carving a Figure: The Female Form	*Ray Gonzalez*
The Router: A Beginner's Guide	*Alan Goodsell*
The Scroll Saw: A Beginner's Guide	*John Burke*

MAGAZINES

WOODTURNING ✦ WOODCARVING ✦ FURNITURE & CABINETMAKING
THE ROUTER ✦ NEW WOODWORKING ✦ THE DOLLS' HOUSE MAGAZINE
OUTDOOR PHOTOGRAPHY ✦ BLACK & WHITE PHOTOGRAPHY
TRAVEL PHOTOGRAPHY ✦ MACHINE KNITTING NEWS
GUILD OF MASTER CRAFTSMEN NEWS

The above represents a full list of all titles currently published or scheduled to be published.

All are available direct from the Publishers or through bookshops, newsagents and specialist retailers.

To place an order, or to obtain a complete catalogue, contact:

GMC Publications,
Castle Place, 166 High Street, Lewes, East Sussex BN7 1XU United Kingdom
Tel: 01273 488005 Fax: 01273 402866
E-mail: pubs@thegmcgroup.com
Orders by credit card are accepted